WESTERN ART

MASTERPIECES

WESTERN ART
MASTERPIECES

T.H.Watkins
and Joan Parker Watkins

Hugh Lauter Levin Associates, Inc.

Copyright © 1996 Hugh Lauter Levin Associates, Inc.
Design: Ken Scaglia
Project development: Fairstreet Productions/Photo*search*, Inc., NY
Editorial production: Deborah Teipel Zindell
Picture research: Photo*search*, Inc., NY
Printed in China
ISBN: 0-88363-596-8

Contents

Introduction: The West as a Way of Seeing

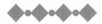

More than twenty years ago, I followed two field agents of the federal Bureau of Land Management across a flat plain of creosote bush and greasewood a few miles north of the Black Rock Desert in the heart of Nevada's arid interior. There was something I needed to see, they insisted, if I was to understand, however incompletely, some of the wild country about which I was getting ready to write a book. Before parking the BLM van on a dirt track with roadlike pretensions and taking me with them, they had sworn me to silence—or at least to artful vagueness—with regard to the actual location of what they were about to show me. I kept that promise then, and I keep it now.

It seemed to me that we hiked for hours through the relentless glare of the day before coming to the edge of an arroyo perhaps forty feet across from rim to rim, twenty deep, and fifteen wide at the bottom. It apparently twisted for miles through the otherwise level flatland. It was called a "river" on the BLM's maps, though the description normally would apply only during the occasional seasons of rain when flash floods ripped through with terrible force, carving the cleft ever deeper over time. We skittered and hopped down an old path through the jumbled piles of ancient, broken rock that lined both sides of the arroyo, then followed its bed for a while before turning a bend and encountering a sight that stopped me in my tracks.

One of the agents grinned and swept his arm past the scene as if he were showing me a favorite room in his own house. On nearly every available flat surface of the boulders on both sides of the arroyo petroglyphs had been incised, hundreds of symbols and figures created by chipping through the dark oxidized surface of the rocks to reveal the lighter stone beneath: coiling circles, carefully designed geometric patterns, jagged

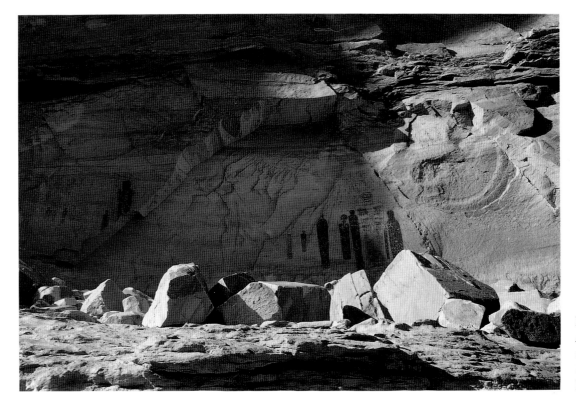

Diane Cook. *Petroglyphs, Horseshoe Canyon, Canyonland National Park, Utah.* Photograph © 1988 Diane Cook.

snakelike lines, godlike yet near-human figures, immediately recognizable depictions of pronghorn, desert bighorn sheep, and other critters of the desert, and jumbled arrangements of any and all of these that may or may not have been a way of recording events of significance, great hunts, terrible battles.

The petroglyph gallery continued for three or four hundred feet down the curving path of the arroyo. It was the Sistine Chapel of petroglyph sites, an explosion of prehistoric artistic expression accomplished by many thousands of individuals over many thousands of years. Much of what was inscribed doubtless was as banal and unremarkable as a grocery list or a telephone conversation doodle. Yet, like the gloriously ornate scenes on Michelangelo's Renaissance ceiling, these crude, dreamlike images lost in a ravine somewhere in the middle of one of the least habitable deserts in the West almost certainly represented, at least in part, the ancient human striving to make sense of the world and of forces that can never be fully defined or comprehended.

So it has always been in the West. If to those long-vanished people, like their descendants whom we came to call Indians (though "Native American" and "First Nations" people are sometimes preferred these days), the land of the West was numinous with the unknown and the unknowable, it was no less so to the Europeans, and later the Americans, who would supplant these older cultures with their own systems of thought, philosophy, methodology, and mythology. And, like their antecedents on this continent, they would turn to the plastic arts to articulate their wonder and curiosity about such an abundance of land and life, seeking so diligently to give physical expression to that which entranced them that the way of seeing the West became, in a very powerful sense, a way of seeing themselves.

Art, of course, is one of the mirrors by which a culture defines itself, and it is hardly surprising to see that fact demonstrated with great vividness and scale on so large a canvas as the western landscape. Consider the intellectual and philosophical baggage that the first Europeans brought to this continent. In *Western Star,* Stephen Vincent Benét's unfinished epic poem about the frontier movement, the author called upon the ghosts of all the land's ancestors to help him understand the moment of the New World's discovery with "something of the wonder and the awe" that must have washed over Columbus and his men.

What the continent was to those first Europeans, the trans-Mississippi West became to the Americans who followed, chasing dreams of ambition and opportunity, or sometimes just escape, across all the rocks and hard places for half a century, building a storied and multifaceted civilization that never ceases to fascinate us, tempting us to find in it what we wish, from simple entertainment to a complex historical validation of the American character, whatever any of us believes that to be. It is probably more of a sociological and psychological burden than the history of any region should be expected to bear, but there is no denying its weight.

Consider the extraordinary dimensions of the narrative even when given the briefest treatment. The dreamers were fairly limited in number, at first. There were the traders: merchants who rumbled long caravans of wagons laden with goods from Independence, Missouri, to the Spanish settlements at Taos and Santa Fe in New Mexico in the 1820s and 1830s; or the fur tycoons whose half-civilized commission men—"mountain men," they were called—were the first American anti-heros, free-market entrepreneurs who followed their quest for pelts into the high country where the wind came down off the Front Range of the Rockies singing, "Come and find me, come and find me." A few explorers, dreamers by government assignment: Meriwether Lewis and William Clark, of course, who between May 1804 and September 1806 trekked the newly acquired Louisiana Territory from the confluence of the Missouri and Mississippi rivers to the

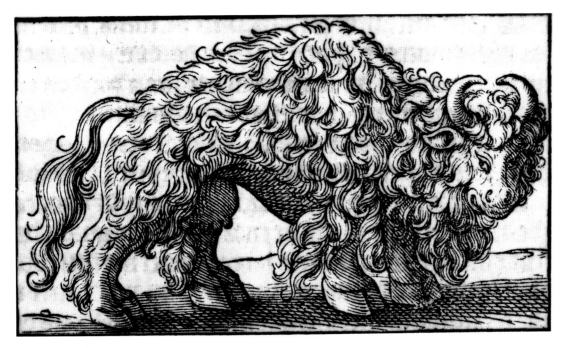

Artist unknown. *Buffalo*. 1554. Woodcut. From *La Historia general de las Indias* by Francisco Lopez de Gomara. Library of Congress.

Map of the Great Falls, Columbia River from *The Journals of Lewis and Clark*. 1805. Missouri Historical Society.

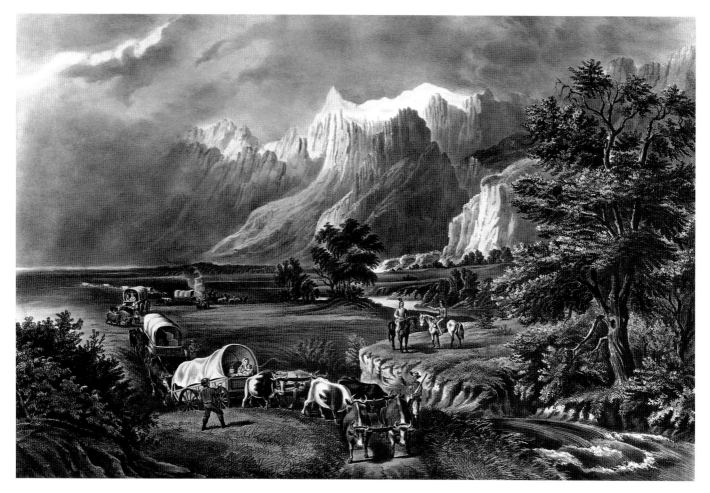

The Rocky Mountains: Emigrants Crossing the Plains. 1866. After Frances Flora Bond Palmer. Published by Currier & Ives. 17 ½ × 25 ¾ in. Amon Carter Museum, Fort Worth, Texas.

mouth of the Columbia River two-thirds of a continent away; Lieutenant Zebulon Montgomery Pike, who followed the Red and Arkansas rivers to their headwaters in Spanish-held New Mexico in 1806 (and got himself arrested as a spy for his trouble); Major Stephen Harriman Long, who investigated the western half of the Mississippi River Valley in the 1820s and called it "The Great American Desert"; and John Charles Frémont, who rose through the ranks from Lieutenant to Captain to Major on three expeditions in the 1840s that took him everywhere from the tangled ancient forests of the Pacific Northwest (a British possession) to the fast-vanishing prairie of California's Great Central Valley and the arid mountain-and-valley complex of the Great Basin (both regions Mexican possessions at the time) and established him as the West's consummate pre–Civil War explorer.

And settlers, of course, always the settlers: first, the Methodist missionaries of the 1830s who trickled into Oregon to bring Christian enlightenment to Indian peoples, some of whom would later resent the intrusion and reject the enlightenment by killing several of the messengers. Then came those who had little more

than land on their minds—wagon train after wagon train of the land-hungry crossing the Rockies year-by-year (nine hundred people in 1843 alone) on the Oregon and California trails to filter into the river valleys of Oregon through the Cascade Range or the Sacramento and San Joaquin valleys of California over the Sierra Nevada, where a group of late-season stragglers called the Donner Party would find themselves in terrible trouble in 1846. Finally, there were the Mormons, the persecuted members of the Church of Jesus Christ of Latter-Day Saints, whom elder Brigham Young led to safety in the valley of the Great Salt Lake in 1847, there to build the only functioning theocracy since the Puritans.

And so it might have remained for years, even after the territories once claimed by the Mexican and British governments were acquired by the United States through conquest and negotiation. The fickleness of fashion had combined with the relentless depletion of fur-bearing animals to kill the fur trade by then, and with the Pacific Coast effectively nailed down by settlement, the interior West—the "profitless locality," one explorer had called it—held little that anyone wanted.

The discovery of gold in California in January 1848 and the consequent Gold Rush of 1849 put the end to quietude, however, inspiring one of the greatest single mass migrations in human history, as tens of thousands crossed the interior West to California in a matter of months, turning the dirt tracks of the trails into wagon-crowded, dust-ridden highways, polluting streams and rivers, consuming square miles of grass, exacerbating relations with Indian peoples who finally began to comprehend the dimensions of the change that was in store for them in the years to come.

When the gold in California proved inadequate to the dreams of greed that had brought the thousands west, pilgrims spilled back across the mountains, prospecting every likely spot for the treasure that had eluded them in the Golden State. And it was there, all right: gold and silver and sometimes copper in all the Anglo-empty territories that would become new American states—Nevada, New Mexico, Arizona, Idaho, Utah, Wyoming, Montana, Colorado, even parts of Oregon, Washington, and the Dakotas. Towns sprouted and died and sprouted again; individual effort was replaced by corporate enterprise and industrial mining; railroads replaced wagon roads; within twenty years, the intermountain West became a scattering of smoking industrial cities pocketed in several million square miles of unsettled wild land.

East of the mining regions another kind of enterprise flourished. In the post–Civil War years, millions of cattle were driven north from Texas, Oklahoma, and Kansas to feed and fatten on the rich grasses of the northern Plains, while government grants and cheap railroad sales of land encouraged the homesteading of the semi-arid Great Plains from Kansas to North Dakota, where waving seas of grain replaced the native grasses. The land of the buffalo became the territory of enormous ranches and farming operations so big that new machines had to be invented just to work them.

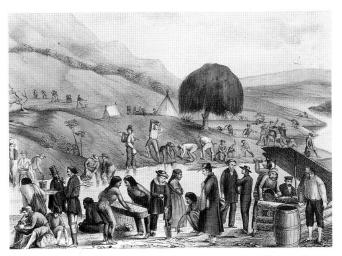

California Gold Diggers: Mining Operations on the Western Shore of the Sacramento River. c. 1850. Hand-colored lithograph. 8 ³⁄₈ × 12 ¹⁄₈ in. Bancroft Library, University of California, Berkeley.

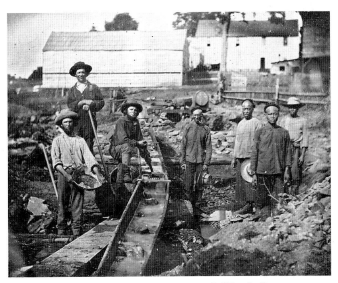

Head of Auburn Ravine. Daguerreotype. California State Library, Sacramento. California Section.

Dude and a waitress taking the prize for dancing "Bull Calves" Medley on the Grand Piano. Harper's Magazine. Engraving.

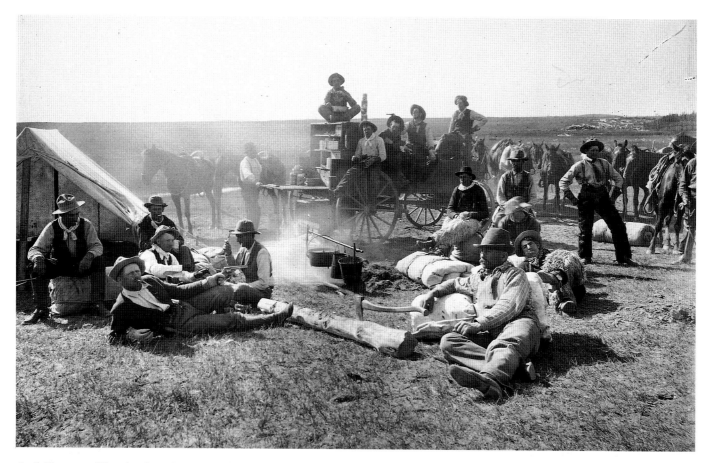

Grub Time at a Wyoming Roundup. 1898. Photograph. Wyoming State Museum, Cheyenne. Stimson Collection.

Everywhere, from the Dakotas to the Sierra Nevada, a new generation of government explorers like Major John Wesley Powell sought out the untapped resources still hidden in the land and outlined the best and most intelligent uses that could be made of them, while disease, alcohol, forced removal, cultural mutilation, intermittent warfare, governmental corruption, and abysmal care reduced the Native Americans from a prideful population of diverse nations to weak and half-starved remnants whose psychic strength alone enabled them to survive into our own time.

The twentieth century (largely ignored in most popular histories of the West, even though responsible for nearly half of that history by now), has added its own chapters to the story, many every bit as transforming as anything the nineteenth century wrought. Begin with the extraordinary booms in cattle and wheat inspired by World War I, then follow with the drought, dust, and depression of the "Dirty Thirties" that sent a whole new population of wanderers across the land. Add the federally funded hydropower and reclamation projects that plugged the Columbia, the Colorado, the Salt, the Missouri, the Snake, and dozens of their big

and little tributaries with dams, permanently changing the natural character of entire river basins. Throw in the development of World War II wartime industries and military installations, while such traditional extractive industries as logging and mining dug and stripped with new energy.

Finally, conclude this abbreviated chronicle with the postwar era, which has seen the population of the West grow from twenty million in 1950 to nearly fifty million in 1990, giving rise to swelling conurbations of immigrants and in-migrants that defy demographic analysis and are prey to all the ills that plague urban America. Meanwhile, just in the background, like a subtext, a growing and increasingly visible environmental movement would have the West turn its back on its most destructive traditions and write a new vision of hope in the still magnificent land that lies between the Big River and the western edge of the North American continent.

Find, if you can, a two-hundred-year history more rich in glory and debauchery, possibility and disappointment. . . . Indeed, find one in which the participants

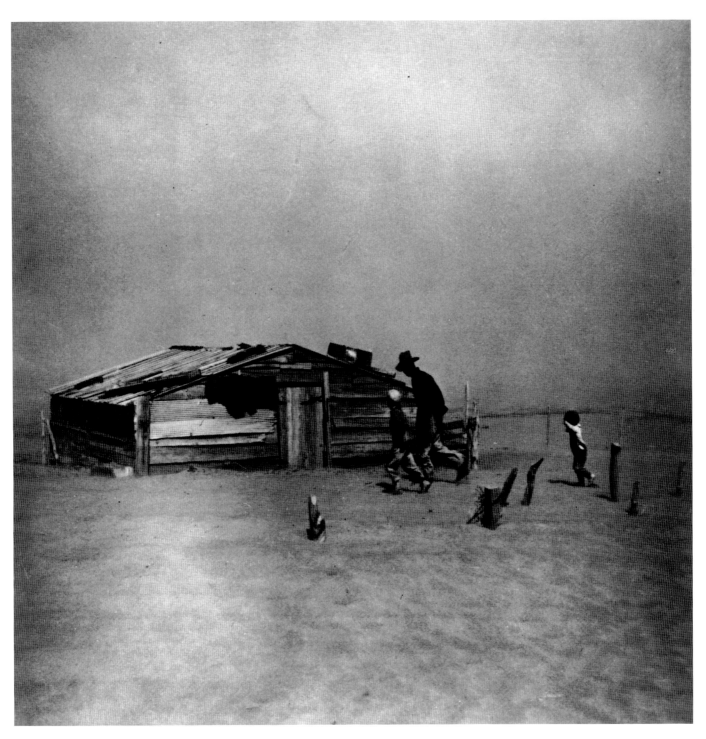

Arthur Rothstein. *Dust Storm, Cimarron County, Oklahoma.* Photograph. 1930s. Library of Congress.

were more thoroughly conscious that they were involved in a great and colorful endeavor—the mountain men who joyously collaborated in fabricating the legends that were attached to their names like scalps to their belts; the thousands of '49ers whose diaries, journals, and letters home documented the Gold Rush more completely than any event in our history until the Civil War; newspapermen who celebrated and embellished the cowtowns and mining camps or the murderous extravagances of thugs given a peculiar nobility as gunfighters; and the cowboys, outlaws, stagecoach drivers, soldiers, military scouts, and even Indians who populated the casts of the Wild West shows of the latter nineteenth century and motion pictures of the early twentieth century, helping to exploit the reality of their history in order to give it the shape of profitable myth.

The drive to picture both the real and the unreal in the history of the West has not been confined to the participants, of course, or even to those who were there as observers. Clearly, the West remains a mirror in which

Colorado miners, Ocean Grove. Photograph. Denver Public Library. Western History Department.

we believe we can find ourselves, for so much of what we are, what we have hoped to be, and what we have and have not failed to become as a people still can be discerned there. In this volume, we have selected forty-eight works of art, from prehistoric pottery to modern Expressionism, that we believe demonstrate with particular clarity not merely the observed or well-imagined reality of the Western experience but something of the emotional content that has gone so far toward defining how we remember and interpret it.

These representative samplings come from one of the richest and most varied traditions of art in any nation's history—that of the thousands of artists and illustrators who have been finding inspiration in the people and landscapes of the American West for nearly two hundred years. And when we include prehistoric and Native American traditions we look back a thousand years. There is virtually nothing in the crowded history of the West that has not been recorded, albeit with varying degrees of skill, by one artist or another, and many of them have gone far beyond mere documentation to help shape the very way in which we have learned to see this place, its history, and its people.

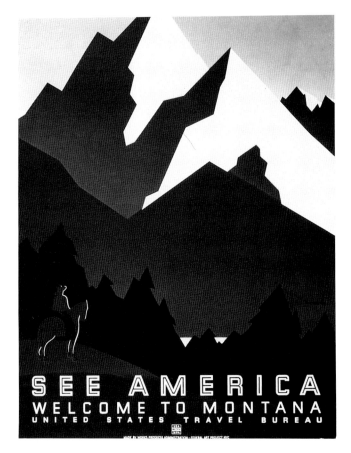

See America. Welcome to Montana. Oil on canvas. 28 × 22 in. WPA. © 1996 Wheatley Press, Los Angeles, California.

George Catlin, for example, entered the country of the High Plains to illuminate the life and character of the resident Native American tribes even before the first American settlers staggered across the Mississippi and Missouri rivers. His graceful, powerful images still burn in the national consciousness. Alfred Jacob Miller, Catlin's successor, immortalized (there is no better word for it) the world of the mountain men and the Indians who interacted with astonishing contentment and mutual profit during the brief interlude of the fur-trapping era. Government artists like Thomas Moran joined exploring expeditions and helped to popularize the wonders of the West and fix it as a *place* in the national mind, despite—but perhaps also owing to—artistic license that presented the emotional as well as the observable aspects of the landscape.

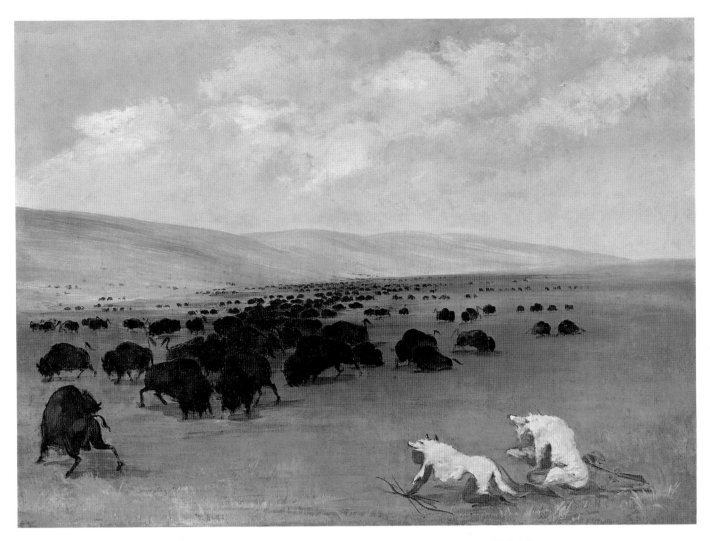

George Catlin. *Catlin and his Indian Guide Approaching Buffalo under White Wolf Skins.* 1846–1848. Oil on canvas. 20 × 27 ⅛ in. National Museum of American Art, Washington, D.C. Gift of Mrs. Joseph Harmsen, Jr.

There were indifferent talents like Joseph Becker and C.C.A. Christensen, who rose above their limitations as artists to provide moments of documented truth; and commercial artists like N.C. Wyeth and Frank Tenney Johnson, whose considerable talents resulted in work that transcended the limits of their assignments. Other artists came West: German Romantics, Impressionists, Post-Impressionists, Abstractionists, Photo Realists, and those of no school at all, like the anonymous lithographer who gave us Horace Greeley on a Concord stagecoach. The Germans, British, French, Native Americans and Mexican Americans, refugees from Chicago, New York, Boston, and other eastern enclaves of respectability—all found an ever-fascinating panorama in the West that freed many of them from the staid artistic traditions of their origins and turned them in directions they could not have dreamed of. And no less powerful are the visions of those like Jaune Quick-to-See Smith who have tried to recreate the essence of long-vanished lives and times from the materials of their imagination, and those like

Charles M. Russell who have captured the authenticity and luminosity of a time and life they lived themselves.

As varied and colorful a group as any who ever joined the national compulsion called the "Westward Movement," helping to fill an old land with new people, these are just a few of the artists who gave us the most durable vision of the West we had in the age before movies and television—and the artists since who have furnished us with a glimpse into the magic and interior beauty of a place that neither the movies nor television can ever fully perceive, however ingenious and dedicated the effort. Whether its value lies in its utility as document or its power as art, however, we believe each of these works illuminates the complexity and power of the greater canvas that is the history of the West.

—T.H. Watkins
Washington, D.C.
June 1995

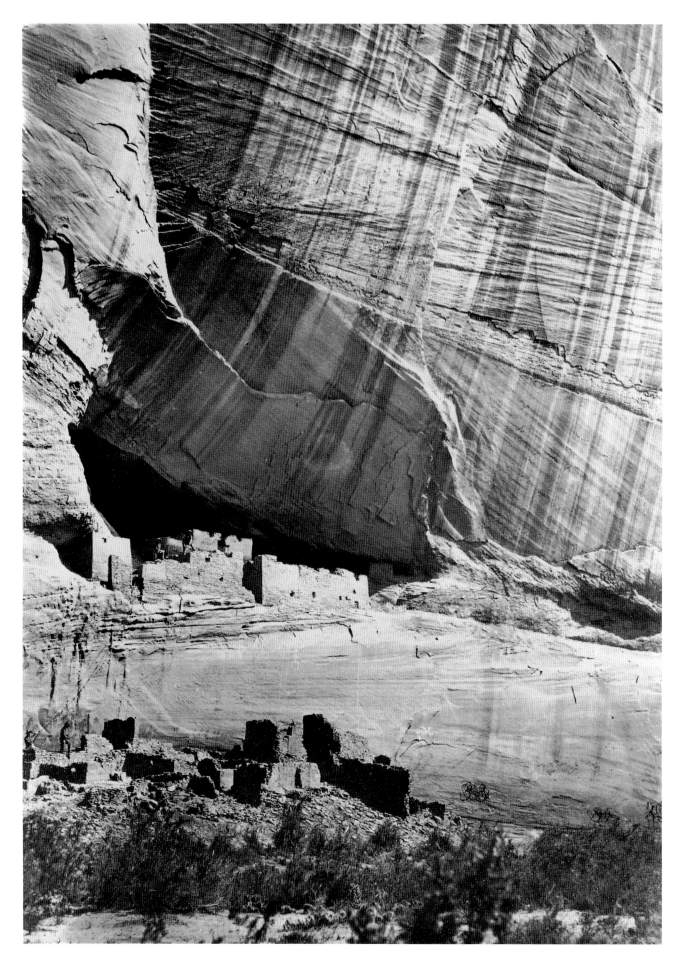

Timothy O'Sullivan. *Cañon de Chelly.* Wheeler Survey. Denver Public Library.
Western History Department.

WESTERN ART
MASTERPIECES

Ramos Polychrome Effigy Jar

c. A.D. 1250–1450

◆·◆·◆·◆

The American Southwest saw the coming and going of a remarkable number of cultures before the arrival of the Spanish in 1540. Throughout the region, there is ample evidence that during the later part of the Archaic period (approximately 1000 to 100 B.C.), small isolated bands of people began to cultivate corn, beans, squash, and cotton. From the first to the fifteenth century, the American Southwest witnessed the growth of diverse complex societies with intricate and unique religious cosmologies, well-developed social traditions and trading systems, sophisticated agricultural techniques (including irrigation), and the construction of both large and small communities on desert floors, mesa tops, stream banks, hilltops, and in canyon walls.

For much of this period (A.D. 500–1350), the Anasazi—a Navajo word meaning "the old ones" or "the people who have vanished"—established themselves as the dominant culture in the northern Southwest. At the height of their prominence, the Anasazi would come to occupy the areas of southern Utah, southern Colorado, northwestern Arizona, and northern New Mexico. Here, everything from simple rock art to complex living sites (such as Chaco Canyon and Mesa Verde) still give testimony to their presence. Between approximately A.D. 1150 and 1300 the Anasazi either abandoned the region or broke into groups still extant such as the Hopi, Zuni, Acoma, or the many northern Rio Grande Pueblos.

In this century, many people believed and argued that long-established trade route connections with Mexican high cultures to the south were responsible for the development of everything in the prehistoric Southwest from social mores to decorative motifs and architectural design. However, in recent years archaeologists in the region have refined earlier data and now suggest that prehistoric Central Mexico had little if any long-term impact on the native peoples of the Southwest. Trade with Mexico, although it surely existed, was probably informal, unaligned, and progressed gradually. If, however, any formal trade with Central Mexico did exist, then the large prehistoric town of Casas Grandes in Chihuahua, 130 miles south of El Paso, may have been a major trade center. Casas Grandes probably reached its highest level of influence between A.D. 1250 and 1450, sharing with its northern pueblo neighbors intricate pottery designs and coloring, particularly those examples that included such marvelously suggestive effigy figures as this jar.

Clay.
8 1/8 × 6 3/4 in.
Courtesy of the Amerind
Foundation, Inc., Dragoon,
Arizona.

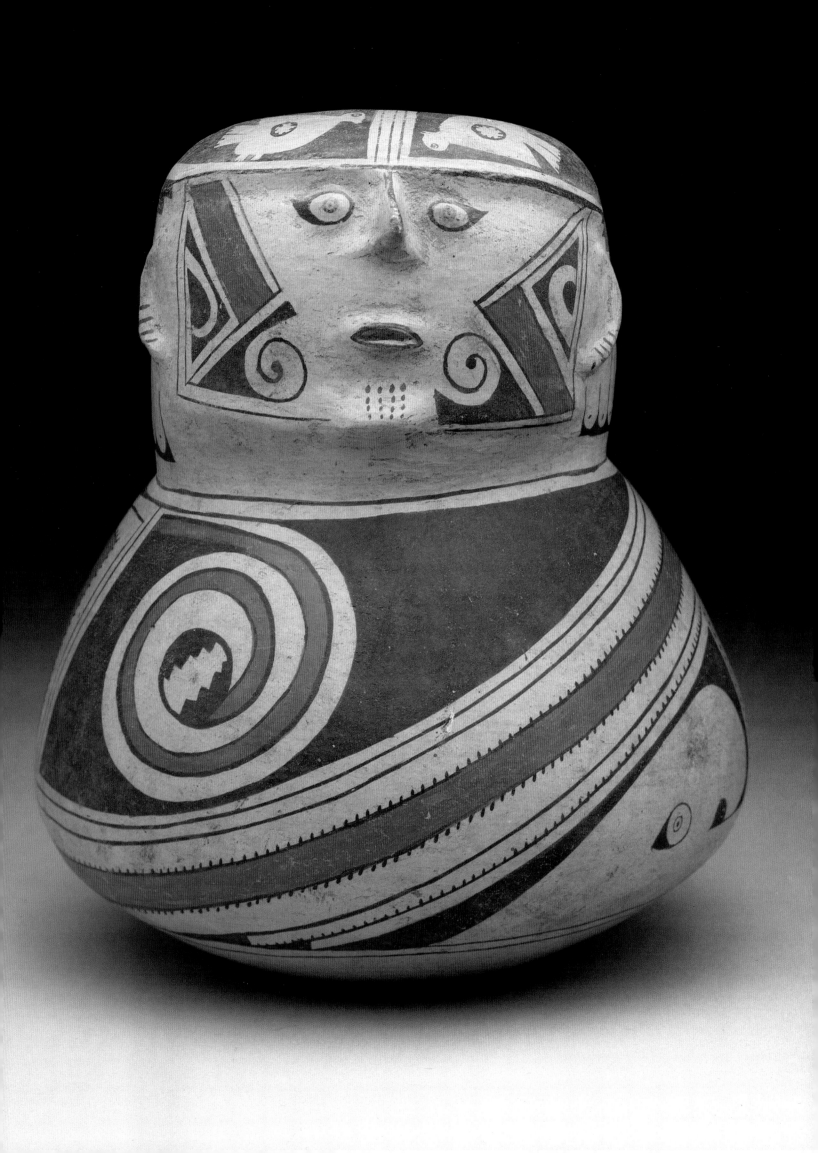

Gros Ventre

Warbonnet

c. 1890

◆•◆•◆•◆

At the time of European contact in the late fifteenth century, there may have been as many as twenty million Native American people in residence in North America, divided up into hundreds of individual nations with distinct cultures, language groups, dialects, and levels of social complexity. That diversity was as apparent in the trans-Mississippi West as it was east of the Big River, from the Haida of the Northwest Coast, with their immense sea-going canoes and highly structured trading economy, to the Paiutes of the Great Basin, whose simplicity of life was honed by the demands of the arid country in which they lived.

In the popular imagination, of course, the dominant image of "Indianness" is that of the Plains tribes, the nomadic people who based their lives on the harvesting of the great herds of buffalo that once followed the grass from southern Canada to west Texas. Among these Siouan-speaking tribes were the Gros Ventre of Missouri, also known as the Hidatsa, who were driven up the Missouri River to the mouth of the Knife River of North Dakota in the late eighteenth century by aggressively expanding Teton-Sioux peoples. Never a very large tribe, the Gros Ventre had dwindled to only about 2,100 people by 1800, and over the next several decades smallpox and other diseases brought by European contact reduced the tribe to such a tiny number that it was contained in a single village. In 1880, the U. S. Government moved the Gros Ventre to the Fort Belknap Reservation with members of the Arikara and Mandan tribes. In the end, historian P. Richard Metcalf has written, the descendants of the three tribes "merged into one group that today can claim no specific tribal identity."

Like the other people of the northern Plains, the Gros Ventre displayed great artisanship in the creation of ritual apparel, like this ornately beautiful ceremonial warbonnet produced on the Fort Belknap Reservation in about 1890. Typically, the bonnet combines a number of materials from both nature and human manufacture, including weasel skins, felt, woolen cloth, beads, and down feathers—but no element was more important than the golden eagle feathers used to create the classic backswept flow of the headdress. As explorer Joseph Nicollet wrote with regard to the Chippewa of Minnesota in the 1830s, for the Plains Indians the plumage of the eagle was sacred, "a guardian, a genius . . . a manito [manitou, or holy spirit] of war. . . ."

Fort Belknap Indian Reservation, Montana.
Golden eagle feathers, down, horse hair, wool cloth, felt, weasel skins, beads.
Length: 33 in.; width: 27 in.
Buffalo Bill Historical Center, Cody, Wyoming. Chandler-Pohrt Collection. Gift of Mr. and Mrs. Richard A. Pohrt.

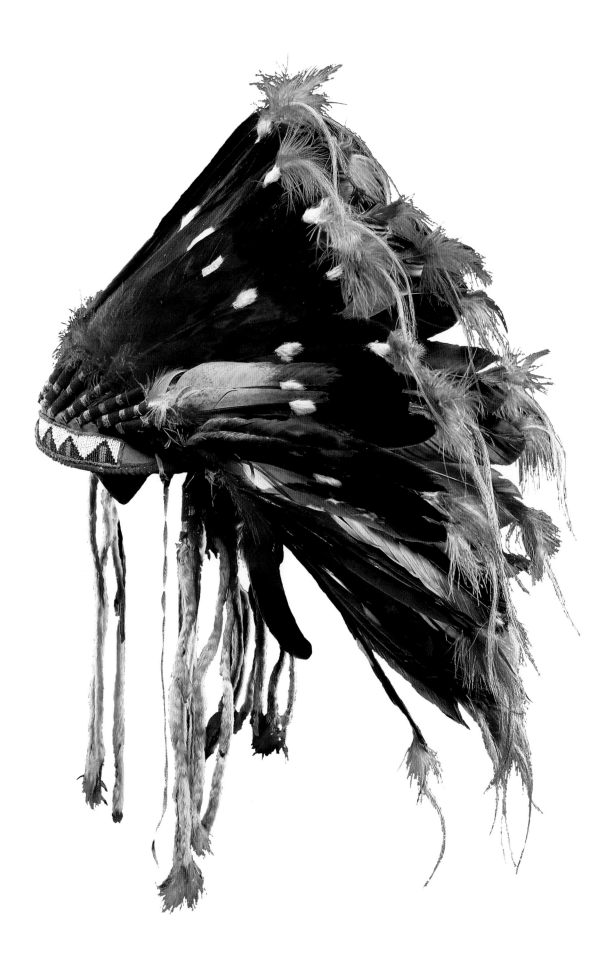

George Catlin
1796–1872

Buffalo Chase, Bull Protecting Cow and Calf

1832–1833

◆•◆•◆•◆

In his classic 1889 book, *American Commonwealth,* James Bryce, British ambassador to the United States, wondered what it must have been like to be among the first Europeans to "burst into this silent, splendid Nature" that was the American wilderness. George Catlin might have been able to tell him, for he was not only among the few non-Indians to venture beyond the Mississippi in the 1830s, he was a self-taught painter of extraordinary energy and great skill. His paintings and written observations comprise one of the most complete records we have of the people of the Plains at that time. Lively, richly colored, and as faithful to reality as his eye could make them, both words and paintings positively sing with a wonder that he never lost while, he wrote in his voluminous notebooks, he wandered "over the almost boundless prairies and through the Rocky Mountains with a light heart, inspired with an enthusiastic hope and reliance that I could meet and overcome all the hazards and privations of a life devoted to the production of a literal and graphic delineation of the living manners, customs, and character of an interesting race of people who are rapidly passing away from the face of the Earth."

The Plains people did not precisely vanish from the Earth, though they were much diminished, and neither did Catlin's work. Shown here is *Buffalo Chase, Bull Protecting Cow and Calf.* "There is an appearance purely classic in the plight and equipment of these warriors and 'knights of the lance,'" he wrote of the Crow Indians, "and they wield these weapons with desperate effect upon the open plains; where they kill their game while at full speed, and contend in like manner in battles with their enemy."

Oil on canvas.
24 × 29 in.
National Museum of American Art,
Washington, D.C. Gift of Mrs.
Joseph Harrison, Jr.

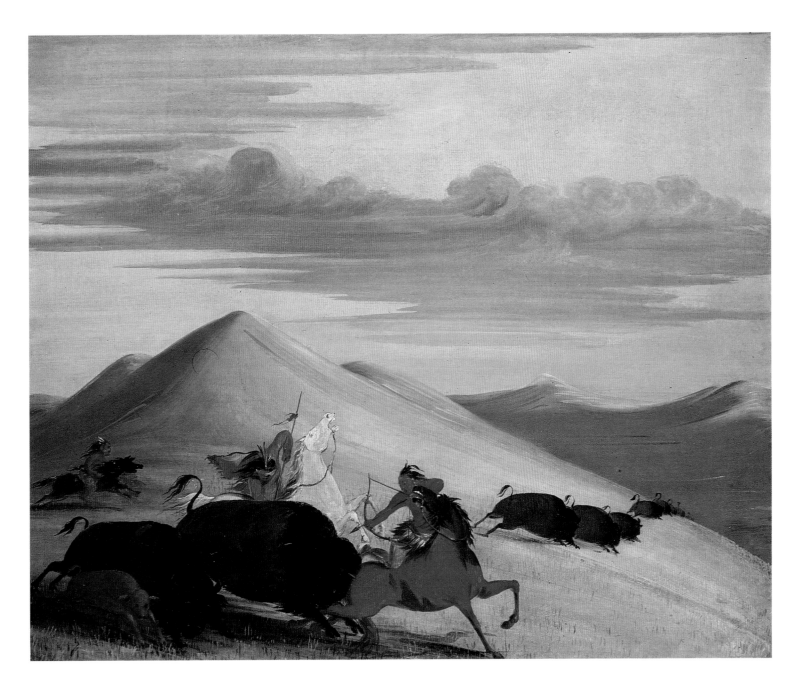

Frederic Remington

1861–1909

A Dash for the Timber

1889

◆•◆•◆•◆

With the possible exception of W.H.D. Koerner in the 1920s and 1930s, the work of no one artist was more influential in shaping how popular culture saw and depicted life in the West than that of Frederic Remington. Beginning his western work in the 1880s, Remington preceded Koerner by a couple of generations; but, like Koerner, he was highly trained (at both the Yale Art School and the Art Students League in New York City) and made his basic living as an illustrator—often of stories that he had written himself—for such magazines as *The Century* and *Harper's Weekly* and for numerous books, including the first edition of Owen Wister's novel, *The Virginian*.

Remington's ability to convey action at full tilt often gave his subjects a highly stylized but nevertheless dramatic, almost visceral power—as in *A Dash for the Timber*. Exhibited at the National Academy the year it was produced, the large painting—roughly four feet by seven feet—was enthusiastically received by critics and the general public alike. Remington was already "one of the best illustrators that we have," a critic for the *New York Herald* wrote, and *A Dash for the Timber* lifted him almost immediately to the ranks of the country's most respected artists. "The drawing is true and strong," the critic continued, "the figures of men and horses are in fine action, racing along at full gallop, the sunshine effect is realistic and the color is good."

In spite of all the cowboys in this painting—many of whom are Mexican *vaqueros* from their appearance—the eye is drawn mainly to the horses, which are the true stars of this vignette, as they frequently are in the artist's work. Remington truly revered the western pony. "He graces the Western landscape," he wrote in an essay in the January 1889 issue of *The Century,* "not because he reminds us of the equine ideal, but because he comes of the soil, and has borne the heat and burden and the vicissitudes of all that pale of romance which will cling about the Western frontier. . . . He has borne the Moor, the Spanish conqueror, the red Indian, the mountain man, and the vaquero through all the glories of their careers; but they will soon be gone, with all their heritage of gallant deeds. The pony must meekly enter the new regime. He must wear the collar of the new civilization and earn his oats by the sweat of his flank."

Oil on canvas.
48 1/4 x 84 1/8 in.
Amon Carter Museum,
Fort Worth, Texas.

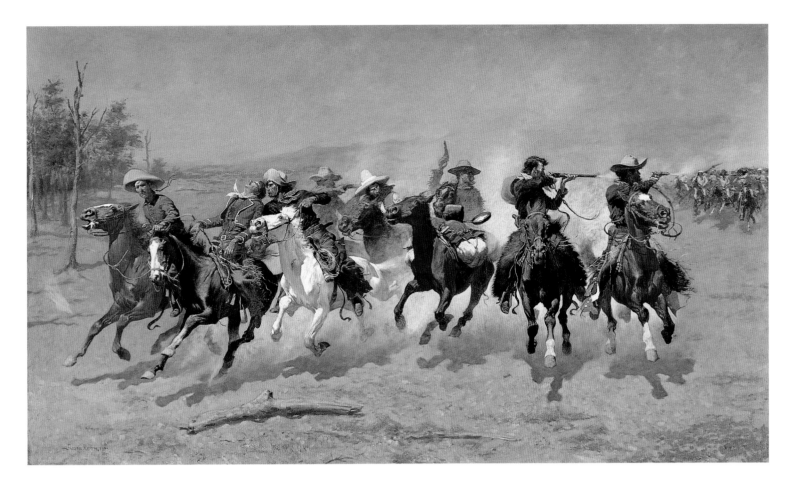

Kicking Bear

Battle of Little Big Horn
c. 1890–1900

◆•◆•◆•◆

No single incident in the history of the American West better demonstrated the singularly inept combination of stupidity and mindless violence that characterized United States Indian policy during the last forty years of the nineteenth century than the Battle of Little Bighorn. Bad policy had driven the Sioux and Northern Cheyenne to leave their reservations and cluster in the valley of the Bighorn River in 1876. The army was ordered to go find them and move them back to where the government said they were supposed to be.

Lieutenant Colonel George Armstrong Custer, commander of the Seventh Cavalry Regiment, was sent by General Alfred Howe Terry to discover where the Indians were concentrated but was ordered not to enter the Bighorn Valley itself. He disobeyed his order and divided his regiment, leaving one troop to guard the horses and sending three other troops off on a scouting expedition. He took the rest of his command down into the valley, where a large encampment of Indians was situated near the confluence of the Bighorn and Little Bighorn. Custer and his men rode right into the middle of the encampment, were driven out and into the hills, then surrounded and killed. "The shots quit coming from the soldiers," Wooden Leg, one of the Northern Cheyenne warriors remembered. "Warriors who had crept close to them began to call out that all the white men were dead. All of the Indians then jumped up and rushed forward. . . . The air was full of dust and smoke. Everybody was greatly excited. It looked like thousands of dogs might look if all of them were mixed together in a fight. All of the Indians were saying these soldiers also went crazy and killed themselves. I do not know. I could not see them. But I believe they did so. . . ."

Kicking Bear's wonderfully intricate pictorial rendition of the battle, like Wooden Leg's reminiscence, cannot be relied on for absolute accuracy. Both, however, manage to capture the powerful excitement of this definitive skirmish between two competing cultures on the Plains. The Indians won this battle, as they had an earlier skirmish at Rosebud Creek; the war, of course, was another matter.

Painted muslin.
Courtesy of The Southwest
Museum, Los Angeles, California.

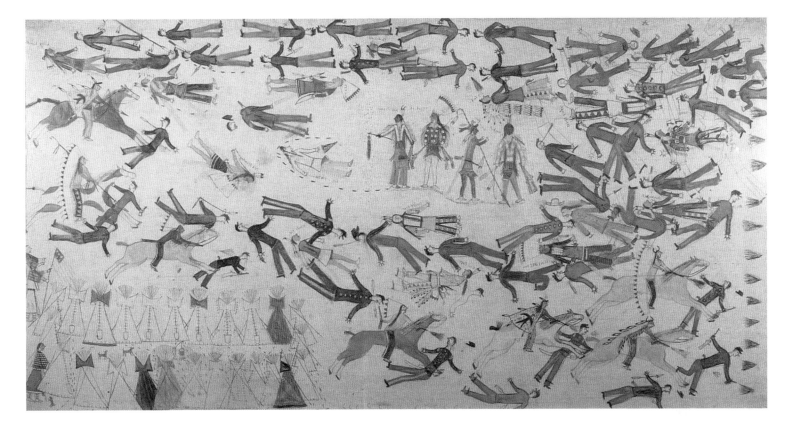

Hugo Wilhelm Arthur Nahl
1833–1889

Californians Catching Wild Horses with Riata

Late 19th century

◆·◆·◆·◆

C ut off from Mexico, their colonizing country, by a perilous land jour-
ney from Sonora or weeks of travel by sea, the first European settlers
of California evolved into a culture almost as distinct as those of the
Indian communities they inexorably displaced. By the 1830s, they
called themselves the *gente de razón*—the "people of reason." These were
the *Californios,* who dominated California between the Sierra Nevadas
and the Pacific Ocean from the beginning of the nineteenth century until
the American conquest of 1846.

After secularization of the California missions in 1821, the *Californios*
seized millions of acres of mission land and on them created one of the
largest and most successful pastoral societies in history, with "cattle on a
thousand hills" and private land holdings that could be measured in the
hundreds of square miles. Cattle were grown less for food than for trade
with American merchant ships sailing around the tip of South America
from eastern ports. Between 1820 and the 1840s, millions of cattle were
slaughtered, stripped of their hides and their fat boiled down into tallow,
both of which were in great demand in the United States.

When one culture overwhelms another, the ascendant people frequently
tend to romanticize that which they have displaced. Nowhere was this
more true than in California, where American writers and artists of the lat-
ter half of the nineteenth century invested the fading *Californios* with the
glow of gentility and color. None were better at this than half-brothers
Charles and Arthur Nahl. Born in Kassel, Germany, in the 1880s, they
studied together at the Kassel Academy of Art, then moved to Paris with
their families in 1846. Political turmoil in France drove them to New York
in 1849, and the lure of the California Gold Rush brought them to
California in 1851, where they tried their hand at mining on the Yuba
River in the Sierra Nevada foothills. That work soon paled, and after try-
ing to eke out a living painting portraits of miners in exchange for gold
dust, they moved to Sacramento, operating from a studio until a fire wiped
out most of the city in 1852. After finally settling in San Francisco, the
Nahl brothers began to churn out portraits, engravings, and other com-
mercial work, as well as paintings and lithographs—like the version of
ranchero work seen here—which attempted to document the past and pre-
sent of their adopted state.

Oil on canvas mounted on masonite.
19 5/8 × 23 3/4 in.
Collection of the Oakland Museum.
The Oakland Museum Kahn
Collection.

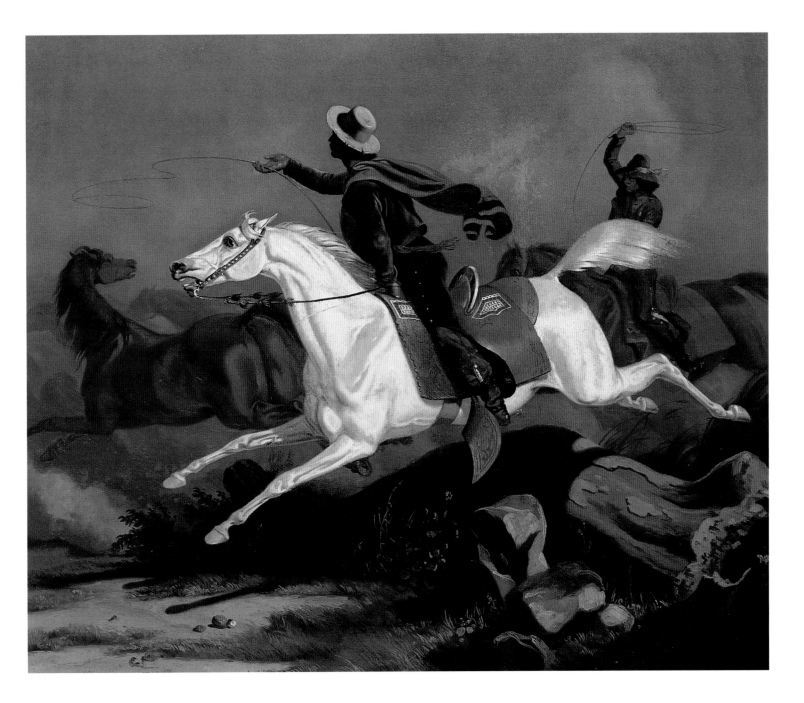

James Walker
1818–1889

The Vaquero

c. 1877

◆•◆•◆•◆

There was, in fact, something of the truth in the romantic view of the lifestyle of the *Californios* in the 1820s and 1830s that has come down to us in story and art. Nurtured by a dependence on the land and wedded to the horse for even the briefest sort of journey, this short-lived culture was marked by the qualities of indolent pride, physical grace, enormous hospitality, and a kind of innocent arrogance, much of which is mirrored in James Walker's elegant 1877 painting of a *vaquero* (though the richness of his and his horse's appointments suggests that this individual was something more than an ordinary *Californio* cowhand).

Walker's interest in the subject of the *vaqueros* came via Mexico itself. Born in England in 1818, but raised and trained as an artist in New York, he had moved to Tampico, Mexico, just before the outbreak of war between that country and the United States in 1846. He served as a scout and artist for the U. S. Army during the Mexican War, and then, after moving back to pursue his career in New York, put his considerable talents to work as a staff artist for the Union Army during the Civil War. At war's end, he lived and worked in several places, including San Francisco, where he maintained a studio in the 1870s and first began to explore what was left of the fast-vanishing world of the *Californios*.

Artists like Walker may have romanticized the *Californios,* but more hard-headed Anglo-Saxon types dismissed them as a relict and irrelevant civilization. Richard Henry Dana, part of the crew of a hide-trading ship and author of *Two Years Before the Mast,* found them to be "an idle, thrift-less people," while Sir George Simpson, director of the Hudson's Bay Company, was even less complimentary in his own spectacularly racist evaluation: "The population of California in particular," he wrote in 1847, "has been drawn from the most indolent variety of an indolent species, being composed of super-annuated troopers and retired office-holders and their descendants. . . . As one might have expected, the children improved upon the example of the parents through the influence of a systematic education, an education which gave them the lasso as a toy in infancy and the horse as a companion in boyhood . . ."

Oil on canvas.
Bancroft Library, University of California, Berkeley.

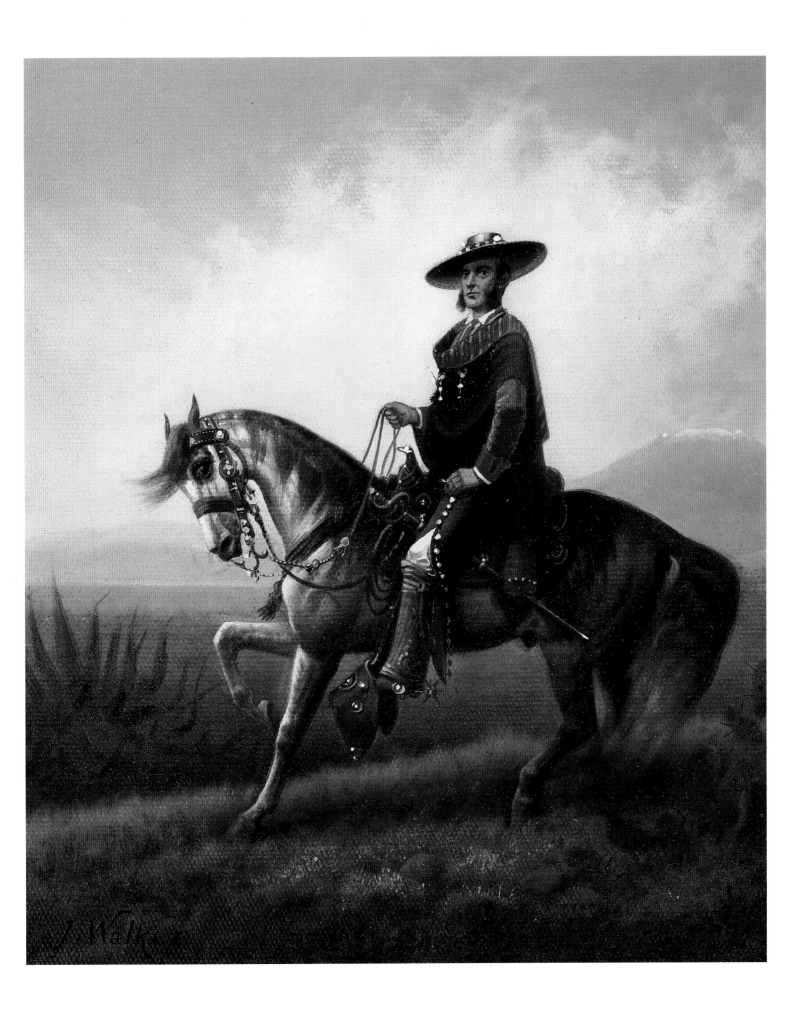

Alfred Jacob Miller
1810–1874

The Lost "Green-Horn"

1837

◆•◆•◆•◆

It was Manuel Lisa of St. Louis, one of the suppliers for the Lewis and Clark expedition of 1803–1805, who opened the American fur trade, but it was John Jacob Astor of New York City who, with the American Fur Company, in 1808 first expanded it into the continent-wide industry it became during the first four decades of the nineteenth century. With entrepreneurs like Astor, William H. Ashley, William L. Sublette, and others establishing trading connections for beaver and other pelts not only in the United States but in Europe and China as well, and with "mountain men" like Jedediah Smith, James Clyman, and Joseph Walker, among dozens of others crawling up all the streams and into all the cul-de-sacs of the land from the Pacific Northwest to the desert Southwest, the fur-bearing critters of the West did not have a chance.

Like that of the *Californios* in the pre–Gold Rush years, the "culture" of the fur trade was a short-lived business, having all but vanished by the middle of the 1840s, the animals largely trapped out and the vagaries of fashion having turned to things other than beaver hats and such apparel. Painter Alfred Jacob Miller was there just in time to see the trade in its last years. Born in Baltimore, Maryland, in 1810 and trained at the Ecole des Beaux Arts in Paris, Miller struggled to make a living as a portrait painter in Baltimore and later in New Orleans before going along as the official artist for the 1837 hunting expedition of Sir William Drummond Stewart, one of several such jaunts that the former British army officer launched in the 1830s and 1840s. After the trip, Miller took his sketches back to Baltimore and spent most of the rest of his life recreating his journeys to the Rocky Mountain West in paintings—including *The Lost "Green-Horn,"* which conveys perfectly the sense of quiet panic that could overcome anyone who found himself alone on the western Plains without a landmark in sight.

Watercolor.
9 7/16 × 12 5/16 in.
Walters Art Gallery, Baltimore, Maryland.

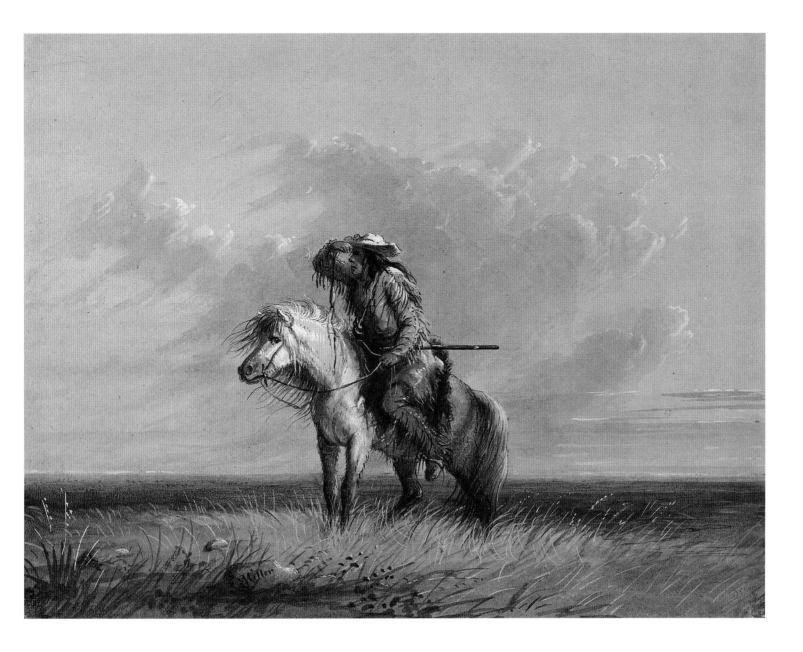

Alfred Jacob Miller
1810–1874

Green River Rendezvous

1837

◆·◆·◆·◆

One of the liveliest and most purely "documentary" of Alfred Jacob Miller's many paintings of the fur trade in the West in the 1830s, *Green River Rendezvous* freezes in time one of the most remarkable phenomena of the West—the annual fur trade rendezvous. These meetings began in 1825, when fur trader and trapper William H. Ashley called for trappers and Indians to gather in a natural "park" along the Green River in Wyoming in the spring to trade the furs they had garnered during the previous season, buy goods, and generally get ready for the new season. The great gatherings, which typically included hundreds of trappers and Indians, continued for nearly twenty years and evolved into colorful celebrations, with horse races, wrestling, and other hijinks. Most resembled the description offered by George Frederick Ruxton in *Adventures in Mexico and the Rocky Mountains,* published in 1847: "The trappers drop in singly and in small bands, bringing their packs of beaver to this mountain market, not unfrequently to the value of a thousand dollars each. . . . The dissipation of the 'rendezvous,' however, soon turns the trapper's pockets inside out. The goods brought by the traders, although of the most inferior quality, are sold at enormous prices. . . .

"The rendezvous is one continuous scene of drunkenness, gambling, and brawling and fighting, as long as the money and the credit of the trappers last. Seated, Indian fashion, round the fires, with a blanket spread before them, groups are seen with their 'decks' of cards, playing at 'euker,' 'poker,' and 'seven-up,' the regular mountain games. The stakes are 'beaver,' which here is current coin; and when the fur is gone, their horses, mules, rifles, and shirts, hunting packs and *breeches,* are staked. Daring gamblers make the rounds of the camp, challenging each other to play for the trapper's highest stake,—his horse, his squaw (if he has one), and, as once happened, his scalp."

Oil on canvas.
26 × 37 in.
American Heritage Center,
University of Wyoming, Laramie.

34

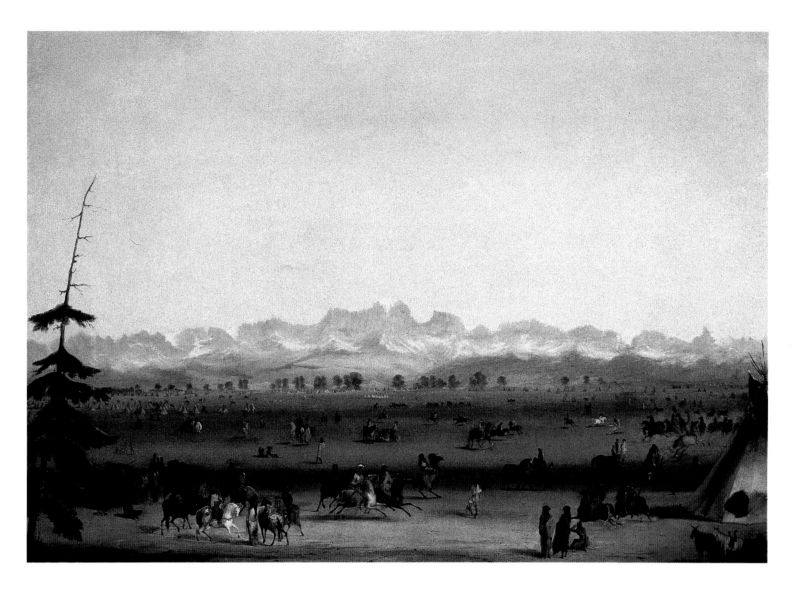

Alfred Jacob Miller
1810–1874

The Trapper's Bride

Mid-19th century

◆•◆•◆•◆

M any a trapper found it difficult to adjust to the white world after a few
seasons in the trade, and many never did return from their wild life.
Which is not to say that they always spent their days (or their nights)
alone under the big sky of the West. Intermarriage with Native
American women was common, though the rituals involved were Indian,
not "proper" Christian ceremonies, and would never have been recog-
nized in the "States" in the unlikely event that a trapper and his wife might
attempt to live there.

The sublimely simple "matrimonial connections," one observer wrote,
"were formed by means of a dower of glittering beads and scarlet cloth,"
and the union generally resembled a business relationship. The trapper
acquired a helpmate who would cheerfully and with spectacular compe-
tence skin and cook the game he brought in, make and maintain his
clothes, set up and break down his tipi, keep his equipment and horses in
good working condition, and bear him children. In return, the Indian
woman received protection, wealth (as it was measured in things like
beads and cloth and other goods), and great standing among her contem-
poraries, as well as treatment that was generally better than what she
ordinarily would have received from an Indian mate. (The lot of Indian
women in most male-dominant tribes was dreadfully hard). Some of the
attachments lasted for years and were as solid and affectionate as any-
thing dreamed of in non-Indian society—though even in this wild country
hearts could be broken.

A Flathead girl whom Alfred Jacob Miller encountered during his 1837
expedition was, he said, "one of the belles of the Rocky Mountains." The
fifteen-year-old beauty captivated one of Miller's young companions, flirt-
ing with him and accepting his presents—and that was all, not even con-
senting to walk with him. Nevertheless, he continued to moon after the
girl to the great amusement of the camp until a fur trapper stole off with
her in the night—to the even greater amusement of the camp. Miller
memorialized his friend's infatuation in *The Trapper's Bride,* perhaps the
most widely known of his paintings.

Oil on canvas.
30 × 25 in.
Joslyn Art Museum, Omaha,
Nebraska.

36

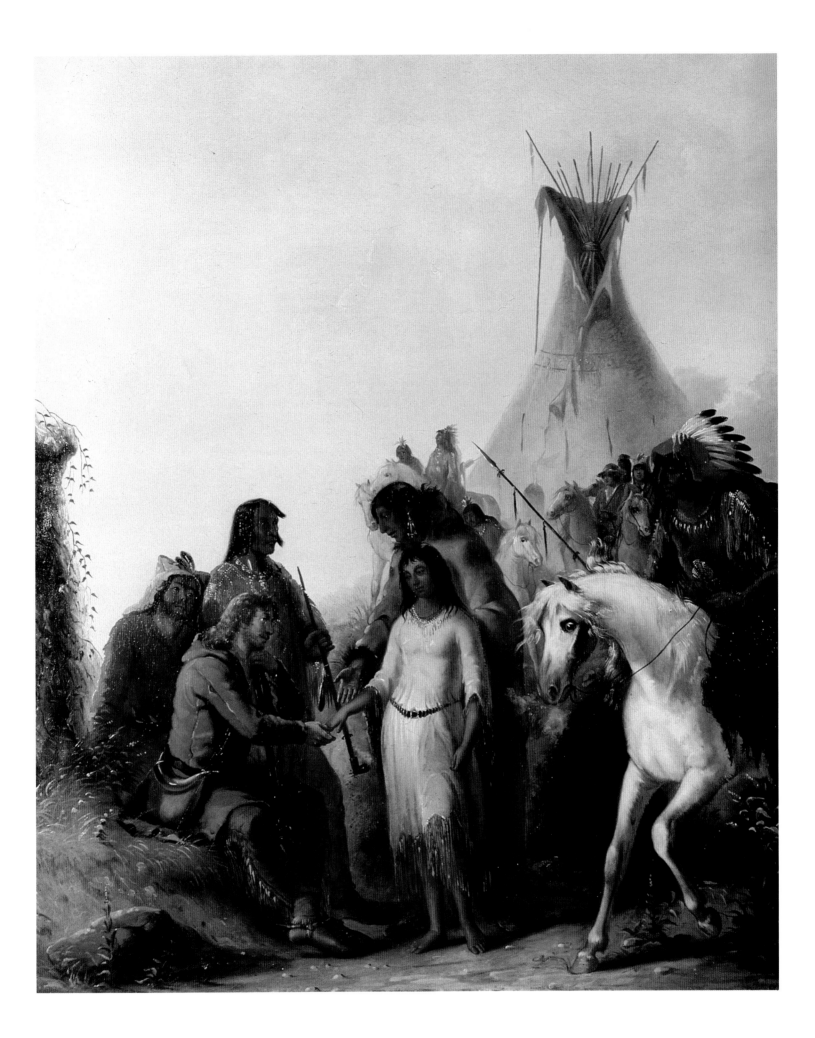

Frank S. Marryat
1826–1855

The Winter of 1849

Mid-19th century

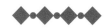

When authenticated news of gold first reached San Francisco in the spring of 1848, the town all but emptied, leaving those who had not gone to the "diggings" with the fear that the place might revert to a lost spot on the map. They need not have worried. As the Gold Rush grew, so did San Francisco, the port of entry for all California, situated on one of the greatest natural harbors on earth.

By the summer of 1849 the fledgling city was described by F.B. Wierzbicki, who said "there is nothing like it on record. . . . Four months ago the town hardly counted fifty houses, and now it must have upwards of five hundred, and these daily increasing. . . . From eight to ten thousand inhabitants may be afloat in the streets."

"Afloat in the streets" was all too true. The streets were appalling—"impassable, not even jackassable," as one wag put it. Rains and rising tides churned dirt walkways into cesspools. It was said that one fellow who attempted to pick up a hat floating on the muck found a man underneath and struggled to free him. "Don't let go!" the muddy one cried. "My horse is in here somewhere."

A place of frantic growth and a boomtown of men, San Francisco revolved around business, speculation, and entertainment. Bars, hotels, boardinghouses, restaurants, gambling dens, brothels, and theaters abounded. By the end of 1849 more than thirty thousand people mixed in a boil of nationalities—all of them in a mad scramble for opportunity. The dream of gold had spawned its first metropolis.

English artist and journal-keeper Frank Marryat fell in love with the West in general and San Francisco in particular, which, he wrote, was "full of fleas and burned down three times a week." He made several trips to the city and wrote and pictured it in *Mountains and Molehills,* published in 1855, the year he died.

Hand-colored lithograph.
5 ¼ × 8 ⅜ in.
From *Mountains and Molehills* by Frank S. Marryat, New York, Harper & Bros., 1855.
Bancroft Library, University of California, Berkeley.

38

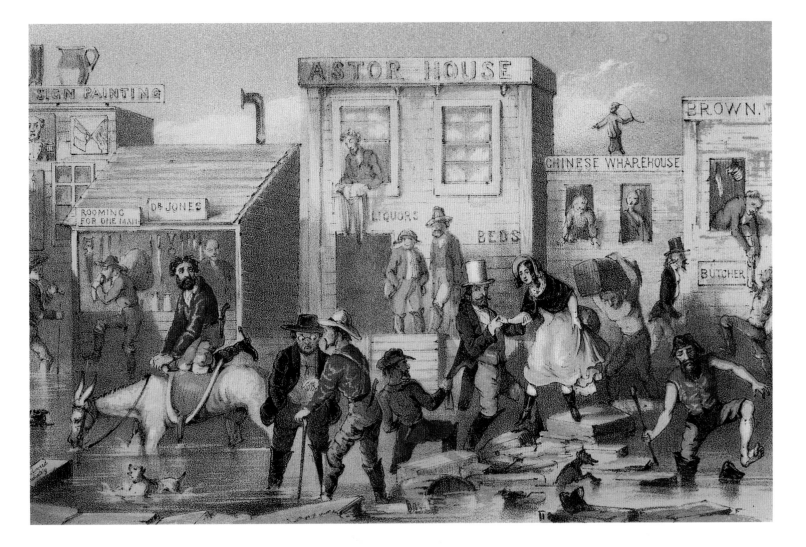

Charles Christian Nahl
1818–1897

Frederick August Wenderoth
1819–1884

Miners in the Sierras
1851–1852

◆•◆•◆•◆

For all the glamor that has since surrounded it, grubbing around after gold was backbreaking work. Much of it was done by former bank clerks, shoe salesmen, and others who had never held a shovel in their hands, much less a pickax. The miner squatted by the side of a cold stream, swishing earth and water around in a shallow, round-bottom pan for hours, hoping for the heart-stopping flash of color indicating the presence of gold; or he kneeled beside a "rocker" or "cradle," a kind of sophisticated version of a pan, moving it back and forth in a constant rhythm, pouring the earth and water in at one end and washing it out the other; or he stood ankle deep in muck, breaking up the earth with a pickax, then shoveling it into one end of a "long tom," a sluicelike wooden trough through which ran a constant stream of water, the gold—if there was any—being caught and held behind slats, or "riffles," in the bottom of the trough, where it combined with quicksilver laid there to trap it.

However he worked, he worked hard, lived in a scrap of a tent, if lucky, subsisted on salt pork and beans, and endured disease and frequently foul weather. And for every tale of a rich strike, there were hundreds of failure, of disappointment and death. Yet still they came—by the end of 1849, there were an estimated eighty thousand miners crawling about the foothills of the Sierra Nevada, looking for the dream that only a few of them would ever find.

Among them were Charles and Arthur Nahl, who lived for a time in 1851 in Rough and Ready, one of the prototypically wild California mining camps. With them was their constant companion, artist Frederick August Wenderoth, a childhood friend from their days in Kassel, Germany, who had studied with the brothers, accompanied them to Paris in 1846 and New York in 1849, and finally went with them to the gold diggings in California in 1851. Like most of those scrabbling around the foothills, Wenderoth and the Nahl brothers were unsuccessful miners; unlike most, they were very good artists indeed, and if this scene—produced by Wenderoth and Charles—is somewhat idealized, as was the fashion of the time, it still manages to capture something of the sweat and perseverance that was required if one were to survive in a landscape that was both beautiful and terribly demanding.

Oil on canvas.
54 ¼ × 67 in.
National Museum of American Art, Washington, D.C. Gift of the Fred Heilbron Collection.

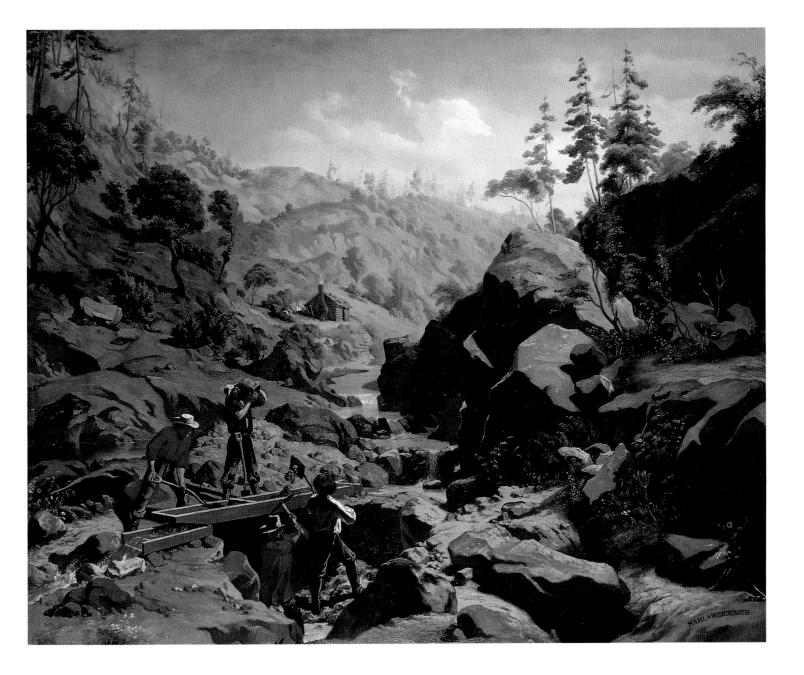

Albert Bierstadt
1830–1902

The Oregon Trail
1869

◆•◆•◆•◆

One of the first painters to create an enduring image of the Far West for the American public, landscape artist Albert Bierstadt was born in the German Rhineland in 1830 and brought to the United States in 1831, but returned to Germany to study when a young man. There, inspired by the eruption of the Romantic Movement, he developed an almost Wagnerian taste for the grandiose; the style characterized his subsequent work in the United States, which until his first trip to the West in 1858 tended toward big, imaginative European landscapes. His romantic style persisted in his work after 1858, resulting in exuberant American landscapes—including *The Oregon Trail,* a lush celebration of the westward movement that positively glows with mythic symbolism.

The first of the great transcontinental "highways," the Oregon Trail was in the 1840s the principle wagon route across the trans-Mississippi West to Oregon. Beginning at Independence, Missouri, and other "jumping off" settlements on the Missouri River, emigrant wagon trains followed the Platte River northwest to Fort Laramie in what is now Wyoming, then crossed the Continental Divide at South Pass, turned more directly north to Fort Hall on the Snake River in what is now Idaho, crossed the Snake River Plains to Oregon and the Columbia River, and finally followed that to its confluence with the Willamette River, into whose rich valley most of the settlers put down new roots—or attempted to.

As Bierstadt's profoundly romantic rendition demonstrates, the pioneers who braved the journey have long since entered the national imagination as individuals who were somehow larger than life, their expeditions symbolizing nothing less than the enduring spirit of the American people. They were brave, and many, perhaps most, were exemplary as citizens, but not everyone was persuaded that they represented anything more noble than a slightly disreputable rootlessness.

Chief among these critics was the Boston Brahmin and historian Francis Parkman, who in 1846 decided to go west along the trail to see what he could see. "A multitude of healthy children's faces were peeping out from under the covers of the wagons," he wrote in *The Oregon Trail.* "Here and there a buxom damsel was seated on horseback. . . . the men, very sober-looking countrymen, stood about their oxen. . . . The emigrants, however, are not all of this stamp. Among them are some of the vilest outcasts in the country. I have often perplexed myself to divine the various motives that give impulse to this migration; but whatever they may be, whether an insane hope of a better condition in life, or a desire of shaking off restraints of law and society, or mere restlessness, certain it is that multitudes bitterly repent the journey. . . ."

Oil on canvas.
31 × 49 in.
Butler Institute of American Art, Youngstown, Ohio.

Frederic Remington
1861–1909

The Coming and Going of the Pony Express
1900

◆•◆•◆•◆

Though it lasted less than two years, the Pony Express became a lasting image of American enterprise and derring-do. Russell, Majors, and Waddell, owners of the Central Overland California and Pike's Peak Express Company (COC & PPE), initially sponsored and financed this short-lived but colorful transcontinental mail service between St. Joseph, Missouri, and Sacramento, California, just before the Civil War.

The first mail run began in April 1860, and covered nearly two thousand miles in ten days for a fee of five dollars per half-ounce of mail. Horses and men had to be young, strong, and reckless—as the company was willing to specify. An advertisement in the San Francisco newspapers shortly before service began read:

> WANTED: Young skinny wiry fellows, not over eighteen. Must be expert riders willing to risk death daily. Orphans preferred. Wages $25.00 per week. Apply, Central Overland Express, Alta Building, Montgomery Street.

"Pony Bob" Haslam and "Buffalo Bill" Cody were among those "skinny wiry fellows" who rode three hundred miles in less than a day, changing horses every half-hour at way stations—approximately 190 of them—established ten to fifteen miles apart all along the route. Mail was wrapped in oiled silk and put in a leather *mochilla,* or pouch. At each station, the rider vaulted from saddle to saddle, *mochilla* in hand, galloping on to outride whatever dared to get in his way.

It is entirely appropriate that this exciting moment in one of the great legends in the western story should have been captured in oils by Frederic Remington, an easterner who wandered in and out of the West for decades to make a living depicting outsized adventures and real and imagined moments of great and stirring drama—even those he had never seen.

Remington lasted a good deal longer than the Pony Express. It lost money, and its first sponsoring company became known as "Clean Out of Cash & Poor Pay Express" (COC & PPE). The route of the ten-day ride influenced the placement of the rails for the transcontinental railroad a few years later, but when the Overland Telegraph was completed in 1861, the Pony Express rode off into history.

Oil on canvas.
27 × 40 in.
From the Collection of the Gilcrease Museum, Tulsa, Oklahoma.

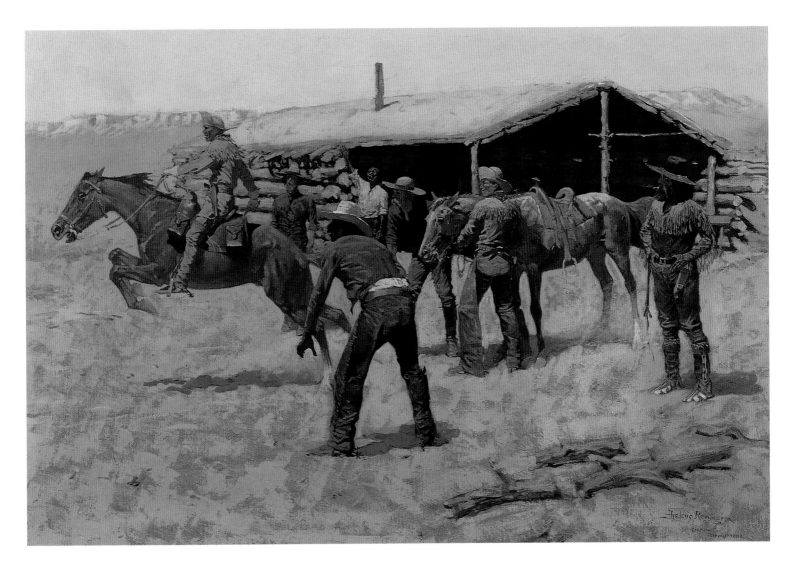

Britton and Rey

California and Oregon Stage Company

Late 19th century

◆·◆·◆·◆

Undisputed belle of all transport vehicles in the the Old West, the Concord coach was as vivid a symbol of those adventurous times as the covered wagon. On both short and long runs, it carried treasure, express, mail, and passengers. It weighed approximately three thousand pounds, cost about $1,400 (the equivalent of about $25,000 in modern money), and carried six to nine passengers inside, plus as many on the top as the luggage allowed.

One of the finest products of American craftsmanship, the stage was manufactured by Abbot, Downing & Company—coachmakers since 1813—at Concord, New Hampshire. It was light, elegant, durable, and fashioned of the finest New England woods. The leather thoroughbraces beneath the coach served as shock absorbers for both horses and passengers, and the cradle effect they produced was so crucial that "an empire once rocked and perhaps depended upon thoroughbraces," according to historian George Hugh Banning.

Painted brightly (red, yellow, green, or blue) and decorated with scroll-work and gold leaf, with perhaps a landscape on the door, Concords were rolling works of art, yet sturdy and reliable enough to be renowned all over the world for excellence. The Concord coach revolutionized western travel; even after the coming of the railroads, many of the coaches served the towns and cities of the West for years, some of them operating into the twentieth century.

Their drivers were often celebrated for both skill and bravery. Jim Miller saved $30,000 of Wells, Fargo & Company gold in the 1860s from two Nevada bandits by driving right through them. As reward, he asked for and received "a damn big bullion watch and chain" crafted from four pounds of Comstock silver. Bandit poet "Black Bart" held up many a Concord, leaving doggerel at the crime scenes. "I've labored hard and long for bread,/For honor and for riches," his most famous quatrain read. "But on my toes too long you've tred,/You fine-haired sons of bitches."

San Francisco lithographers Britton & Rey made several versions of this scene with slight variations in each. In this one, newspaper publisher Horace Greeley—of "Go West, young man, go West and grow up with the country!" fame—sits next to a bearded Hank Monk, probably the most famous driver of them all.

Colored lithograph.
16 11/16 × 23 7/16 in.
Bancroft Library, University of California, Berkeley.

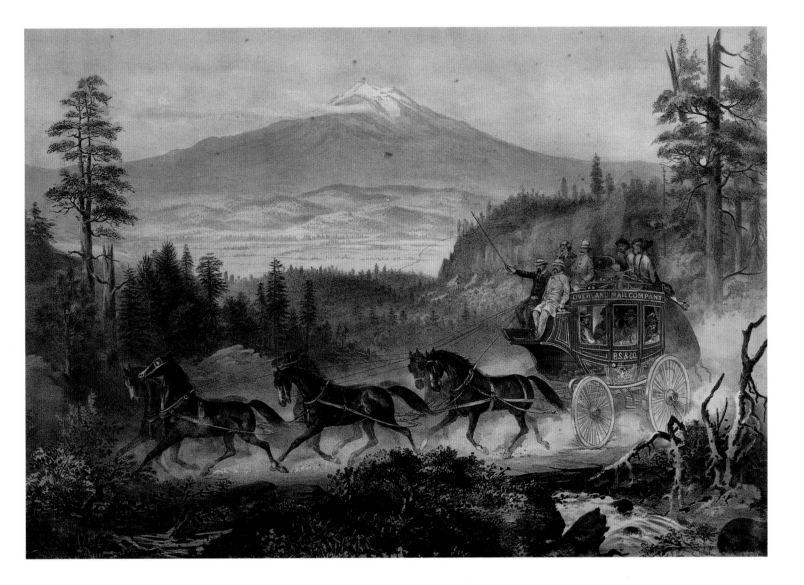

W.H.D. Koerner
1879–1938

Madonna of the Prairie
1921

◆·◆·◆·◆

When I saw that girl on the wagon seat I exclaimed aloud. 'Oh Boy! Dar she!' I don't know when an illustration has hit me in the face the way that one has. Tell Koerner that this is the first time in my career that an artist has really pleased me with his work."

"That girl" was Molly Wingate, heroine of *The Covered Wagon,* and the delighted observer was Emerson Hough, author of the book, an epic of the Great Migration to Oregon in 1843 that first appeared as a series in *The Saturday Evening Post* in 1922. Of the twenty-four paintings which W.H.D. Koerner produced as illustrations for the book, the "portrait" of Molly was the one chosen to appear on the cover of the *Post* issue that included the first installment. Framed by the background of the wagon's covering and haloed by its opening, Molly became a veritable "Madonna of the Prairie," a cover girl and an icon. With her demure dress and aspect, pretty shawl, and cameo —hardly a hair out of place—she was the idealized version of the pioneer woman.

In reality, the trek West could undermine both the health and the mind of a prairie madonna. There were those who dreaded the endless plains and uncertain future in a dangerous wilderness. Tired and worn, some became depressed and tried to turn back. Accounts tell of women who stole horses and rode east, set fire to their wagons, or threatened to kill their children.

William Henry David ("Big Bill") Koerner produced more than five hundred paintings and drawings for over two hundred later western stories. Historian W.H. Hutchinson, author of *The World, the Work, and the West of W.H.D. Koerner*, the definitive biography of the artist, numbers him among the most talented, productive, and versatile of the artist-illustrators for the "big slicks," the mass circulation magazines of the 1920s and 1930s, whose stories and illustrations went a long way toward implanting in the American imagination a permanent image of the-West-that-was.

Oil on canvas.
42 1/8 × 36 3/8 in.
Buffalo Bill Historical Center,
Cody, Wyoming.

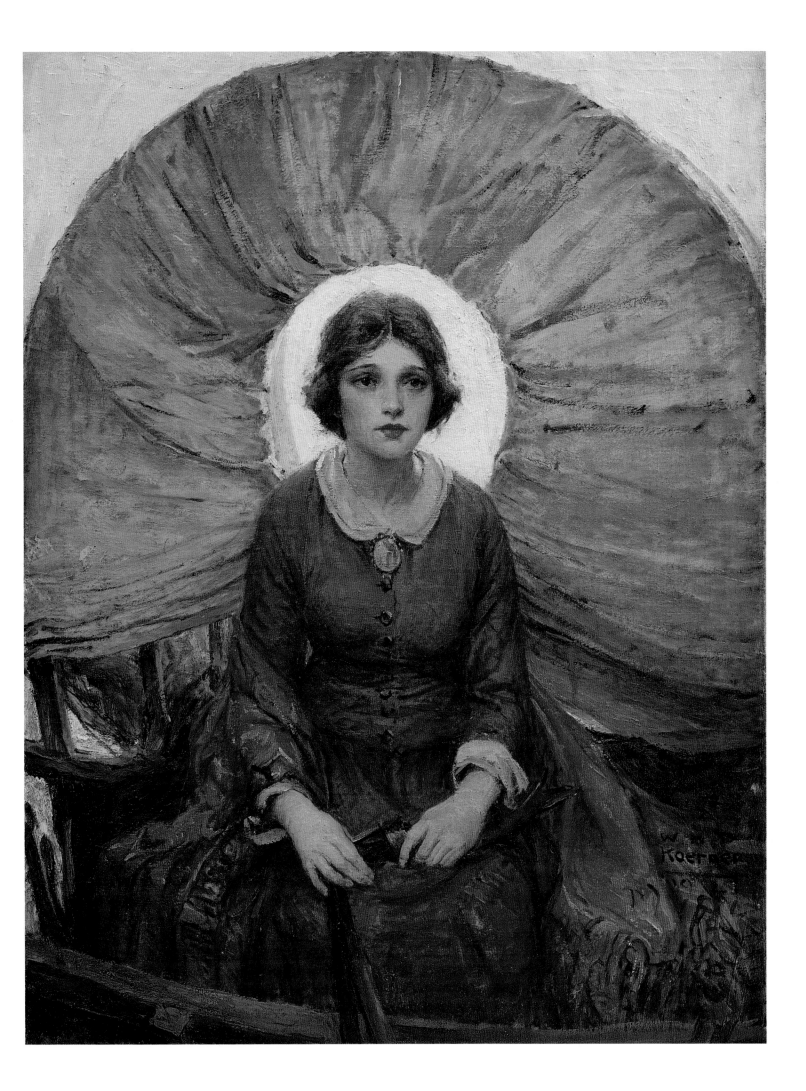

C.C.A. Christensen
1831–1912

The Handcart Company
1900

For some must push and some must pull
As we go marching up the hill,
As merrily on the way we go
Until we reach the Valley, oh.

So sang the handcart pioneers. Their faith placed in God, their eyes fixed on the Promised Land, pulling and pushing handcarts that held all they owned, nearly three thousand Mormon emigrants set out to walk to Zion—the Salt Lake Valley—between 1856 and 1860. The trip was almost 1,400 miles from the Missouri across the Plains and through the Wasatch Range of Utah, but their intention—"So impudent it was almost sublime," wrote historian Wallace Stegner—never wavered.

The handcart scheme was the idea of Mormon leader Brigham Young. As early as 1851, he suggested that if gold seekers could walk to California, Mormons could walk to Utah. But the handcarts proved fragile and the terrain rough, and many pioneers were women, children, and the elderly. All were green and untested, and despite their faith, hundreds succumbed to the hardships of weather, disease, hunger, and exhaustion. The first three parties of 1856 made good time, but the last two that year started late and were caught in blizzards. Later parties learned from their mistakes, however, and between 1856 and 1860 ten handcart companies completed the journey—certainly one of the most remarkable experiments in western travel.

The lucky Saints pictured in this engaging primitive by Carl Christian Anton Christensen (commonly called "C.C.A.") appear to have reached the green pastures beside the still waters promised by the Psalmist. Christensen knew his subject firsthand, though he painted from memory. In 1857, a Mormon convert, he migrated from Denmark to America with his Scandinavian wife. Proudly flying the Danish flag from their two-wheeled hickory handcart, they trekked from Iowa City to Utah. "History will preserve much but art alone can make the suffering of the Saints comprehensible for the following generation," he wrote. Apprenticed both as toymaker and painter, Christensen studied art sporadically throughout his life, and in later years painted monumental narrative scenes depicting the history of the Latter-Day Saints.

Oil on canvas.
25 3/8 × 38 5/16 in.
Museum of Church History and Art, Salt Lake City, Utah.

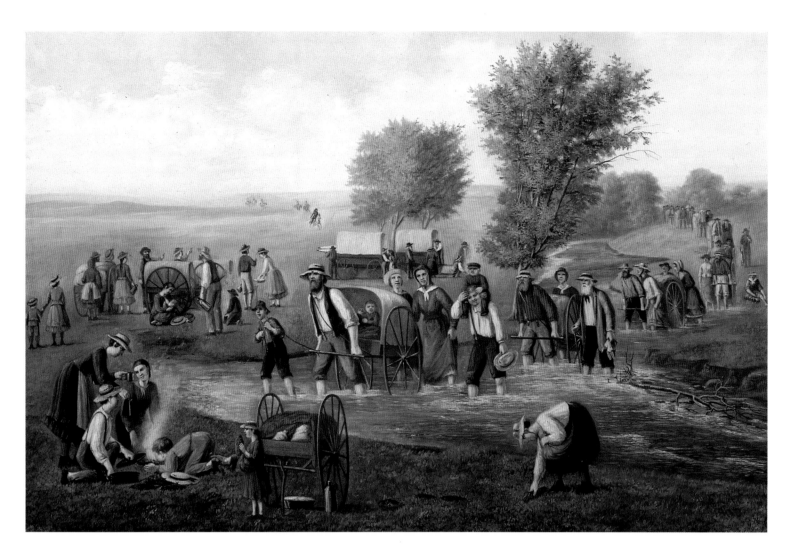

Joseph Becker
1841–1910

Snow Sheds on the Central Pacific Railroad in the Sierra Nevada Mountains
Late 19th century

◆•◆•◆•◆

The construction of the transcontinental railroad began in Sacramento, California, and Omaha, Nebraska, in 1863, and continued until May 10, 1869, when the rails of the eastward-building Central Pacific Railroad were joined to those of the westward-building Union Pacific Railroad with a golden spike at Promontory, Utah. It was called the "Great Work of the Age," and when the telegraph signal announcing the laying of the last rail reached both coasts, bells rang and there was dancing in the streets, and in San Francisco, at least, not a few magnums of champagne were consumed. The United States, it was commonly believed, finally was one nation tied together by parallel lines of steel across two thousand miles of landscape.

There were a few Irish laborers included in the photographs of that great moment in 1869, for they had built most of the Union Pacific's segment. Notably absent, for the most part, however, were those who had built most of the Central Pacific's segment, for these were Chinese whose contribution to the "Great Work of the Age" was only barely acknowledged—though E.B. Crocker, a Central Pacific executive, did note approvingly that "they prove nearly equal to white men in the amount of labor they perform, and are far more reliable. . . ." Ultimately, the railroad employed nearly fifteen thousand Chinese, veterans of the Gold Rush years who had come to the "Gold Mountain" of California in the 1850s to seek their fortunes and, like the rest of the goldseekers, return home richer than their dreams could imagine. Like most, they had failed to find riches and had remained in the state to work at what they could.

Joseph Becker, a newspaper artist who made one of the first trips on the transcontinental railroad after its completion in 1869—and later became head of the art department for *Frank Leslie's Illustrated Newspaper* in New York, producing or supervising the production of thousands of engravings between 1875 and 1900—gave the Chinese railroad workers a deserved place in the iconography of the era. In this charming view, it should be noted, it was the Chinese waving to the passing locomotive who had built the dozens of "snowsheds" in the Sierra Nevada that enabled such trains to cross the mountains even in the winter.

Oil on canvas.
19 × 26 in.
From the Collection of the Gilcrease Museum, Tulsa, Oklahoma.

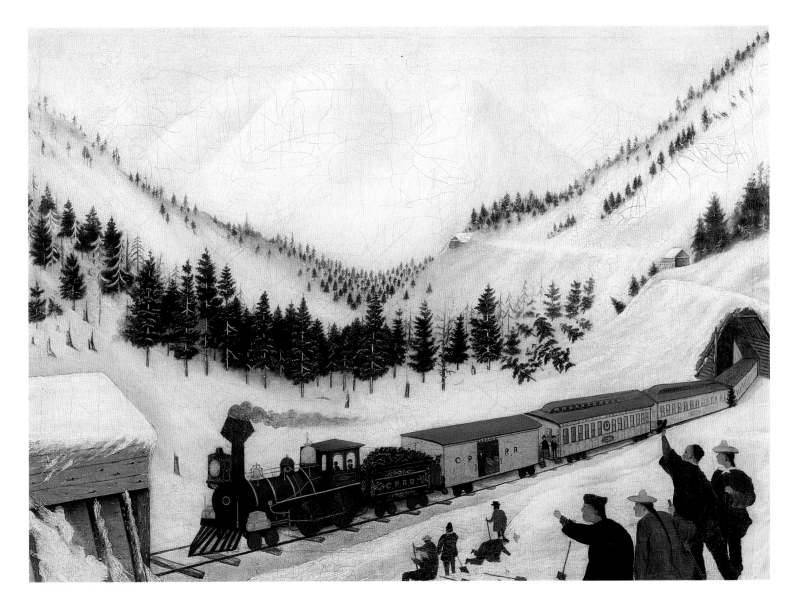

Thomas Moran
1837–1926

Cliffs of the Upper Colorado River, Wyoming Territory

1882

◆•◆•◆•◆

"The old idea that art is best defined as painting nature as it looks . . . does not satisfy me," Thomas Moran once wrote. "An artist's business is to produce for the spectator of his picture the impression produced by nature on himself." As this splendiferous scene illustrates— the redrock country of the upper Colorado River is very beautiful, but does not loom with quite such overpowering drama as the artist gives it here—Moran was capable of altering nature to suit his purposes, which he defined simply as presenting a "true impression of pictorial nature. I place no value on literal transcripts from nature."

The painter and his family came to the United States from England in 1844, but he returned to Europe to study. In 1871, he traveled west as an artist with the government geological expedition led by Ferdinand V. Hayden, trekking into the relatively unexplored region of the upper Yellowstone River. Moran helped to capture the imagination of the public through his paintings of the area, and these, together with photographs made by William Henry Jackson, not only persuaded Congress to fund future explorations in the West, but also inspired Congress to set aside the Yellowstone region as the country's first national park in 1872.

The year following his journey to Yellowstone, Moran went to California to paint the Yosemite Valley (this, too, would become a national park in 1890), and in 1873 he joined Major John Wesley Powell's exploring expedition on the Colorado Plateau. Again, Moran's pictures, together with the work of several photographers and Powell's own reports and lectures, helped "put the hitherto unknown canyons of the Colorado into ten thousand parlors," according to Powell's biographer, Wallace Stegner, "and started the Grand Canyon toward becoming . . . a symbol of natural majesty that has totally displaced the shopworn Niagara Falls."

Oil on canvas.
16 × 24 in.
National Museum of American Art,
Washington, D.C. Rogers Fund.

54

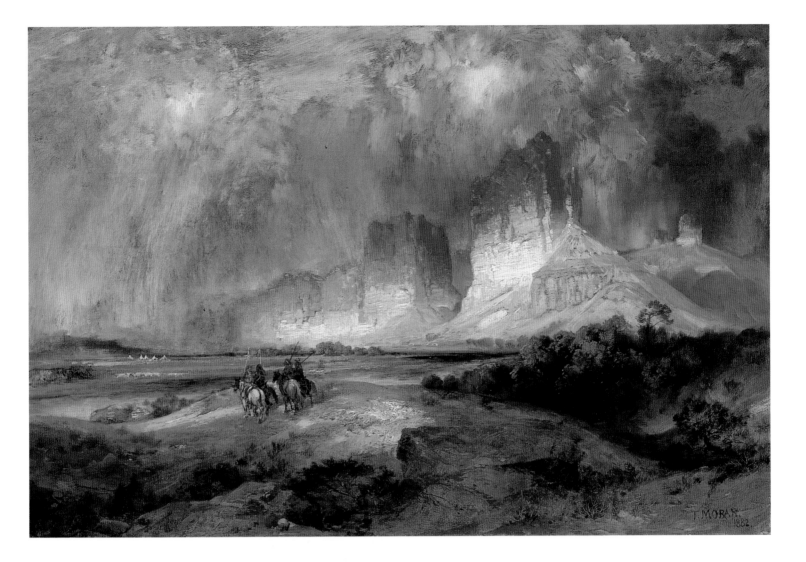

Albert Bierstadt
1830–1902

Long's Peak, Rocky Mountain National Park
1877

◆·◆·◆·◆

The naturally spectacular Rocky Mountains did not need the outsized embellishments of an Albert Bierstadt—but as this painting demonstrates, that did not stop the German-born artist. *Longs Peak, Rocky Mountain National Park* was commissioned in 1876 by Bierstadt's friend and patron, the Earl of Dunraven, who owned much of what later became Rocky Mountain National Park. The painting is a classic example of Bierstadt's monumental vision, and one of many huge Rocky Mountain scenes for which Bierstadt became most famous.

In 1858, the young artist had joined a military expedition under General F.W. Lander ordered by the Department of the Interior to survey a wagon road from Fort Laramie in Wyoming to the Pacific Ocean. Awestruck, Bierstadt worked feverishly, returning to his home in New Bedford, Massachusetts, with hundreds of sketches of mountain scenes, animals, and Indians, which he proceded to render in oils. In 1860, the first of his many looming Rocky Mountain landscapes won acclaim at the National Academy of Design and Bierstadt's election to that august body—at the age of thirty, the youngest artist so honored. Three years later, on a second western trip, he set out for San Francisco by overland stage with journalist Hugh Ludlow. In Salt Lake City they were entertained by Brigham Young, and in California packed into the Yosemite Valley. Bierstadt's work later helped contribute to the valley's fame.

Enormously popular, Bierstadt's paintings commanded record prices from the 1860s through the 1880s, making him a wealthy man. He produced several western landscapes for the U. S. Capitol Building in Washington, D.C., and in 1885 began a series on the wild animals of North America. Called "Father of the Rocky Mountain School of American Painting," Bierstadt remained an unabashed romanticist who used color and massive forms to produce dramatic, almost theatrical impressions. Like Thomas Moran, he made no apology for arranging the elements in his work to suit his painterly needs, and even moved the occasional mountain. Art fashions began to change in the early 1880s, however, and Bierstadt's panoramic views and big landscapes fell from favor. His brand of romantic aggrandizement became passé, and when he died in New York in 1902, he was almost forgotten. He has long since been rediscovered, and even if you know that what you see is not reality, but Bierstadt's distorted vision of reality, it is still difficult to stand before these enormous canvases without open-mouthed astonishment.

Oil on canvas.
5 ft. 2 in. × 8 ft. 2 in.
Denver Public Library,
Western History Department,
Denver, Colorado.

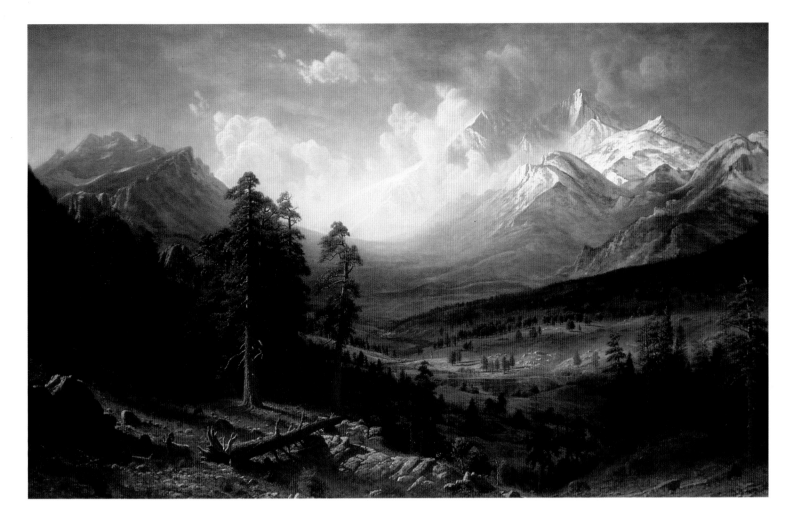

William Hahn
1829–1887

Yosemite Valley from Glacier Point
1874

◆•◆•◆•◆

Aview that suddenly breaks upon us in all its glory far and wide and deep. A new revelation in landscape," wrote naturalist John Muir of California's Yosemite Valley. The Indians who originally lived in the valley called it *Ahwahnee*—"the place of the deep grass." They were soon enough driven out. In 1851, James Savage, an Indian trader, led the first whites into the region to punish a band of Indians who had burned down his trading post. The tourists soon followed. In 1855, the first party arrived, led by James M. Hutchings, who wrote articles publicizing the magnificent scenery, and in 1864 Congress gave the area to the state of California for a park. The valley became a mecca for travelers.

John Muir first saw the Yosemite Valley four years later. "Tired, nerve-shaken, overcivilized people," he wrote in 1868, "are beginning to find out that going to the mountains is going home; that wilderness is a necessity; and that mountain parks and reservations are useful . . . as fountains of life." And he was right. The beauties of Yosemite were popular because of the paintings, drawings, photographs, and stories (some by Muir himself) that they inspired.

Among the artists on hand was William Hahn. A German painter who spent several years in San Francisco, Hahn produced storytelling pictures that combined people with landscape. Trained in the best schools in Europe, he painted exceptional scenes of everyday life that made his fortune and helped to document the character of life at that time. *Yosemite Valley from Glacier Point* is one of his most noted works of this type. In typical genre style, when contrasted with the spectacular, even exaggerated dimensions of landscape in the works of Moran and Bierstadt, the power of Yosemite here is muted, secondary in interest to the spectators gathered on the rim of Glacier Point; in reality, the actual scene from this vantage is infinitely more dramatic than Hahn's quiet vision suggests.

Though California pledged to protect the stunning beauty of Yosemite, Muir was persuaded that such promises were empty. Largely because of his writing and political agitation, Yosemite National Park was created in 1890 and remains today as one of the "crown jewels" of the National Park System.

Oil on canvas.
27 ¼ × 46 ¼ in.
California Historical Society, San Francisco. Gift of Albert M. Bender.

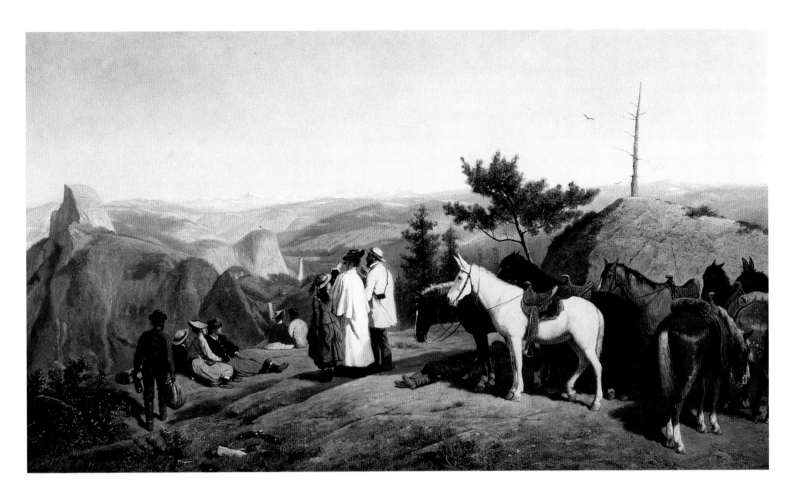

Charles M. Russell
1864–1926

A Mix Up
1910

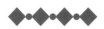

The greatest era of the range cattle industry, like that of many another western enterprise, was relatively brief, roughly spanning the period from the end of the Civil War to the turn of the century. Not very long, perhaps, but long enough for the cowboy to enter the annals of legend so firmly that in the popular mind of that generation and for all those that followed, he became little more than a rambunctious myth.

Artist Charles M. Russell, who worked as a cowhand in Montana in the 1880s and 1890s before marrying a woman who helped him parlay his natural talent into a respectable fortune, played his own part in helping to spread the gloss of romanticism over the image of the cowboy. But in his best work he memorialized the harsh and hardworking reality of the everyday world of the cowhand with greater faithfulness and vigor than any artist of his own time or since.

Russell, like any other experienced hand, knew perfectly well that there was little glamor to be found in sleeping out with the dry stock and drinking from water puddled in a cow track, eating beans day after day, getting your feet stepped on by cows, getting bitten by recalcitrant horses, eating dust for hour after hour while riding drag and staring at the filthy back ends of a bunch of cows, curling up in a bedroll and getting rained on before dawn, riding fence and restringing broken barbed wire, chasing after mavericks through mesquite thickets tight enough to strip you from your saddle, getting thrown and trampled and otherwise damaged in such moments as that documented in *A Mix Up*. The deceptively simple attempt to rope one critter in the bunch suddenly has erupted into a potentially disastrous entanglement.

In short, the measure of a man in cow country had little to do with six-guns and saloon fights and everything to do with how one conducted one's life in that difficult arena where human character was tested.

Oil on canvas.
30 × 48 in.
The Rockwell Museum, Corning, New York.

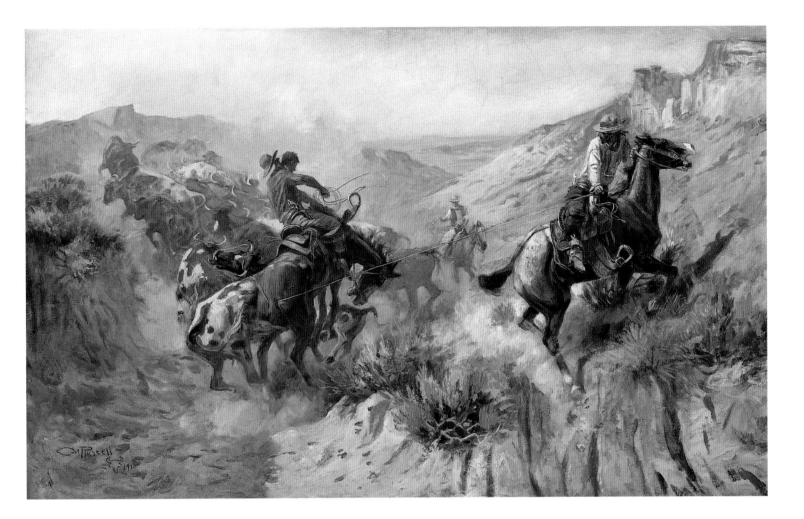

N.C. Wyeth
1882–1944

The Lee of the Grub-Wagon
1904

◆·◆·◆·◆

Like W.H.D. Koerner, N.C. Wyeth, founding father of a painterly dynasty that included son Andrew Wyeth and grandson Jamie Wyeth, made the great bulk of his living illustrating books and magazine articles. He was born in Needham, Massachusetts, in 1882, and studied under the great nineteenth-century illustrator Howard Pyle before launching out on his own as a freelance illustrator—with immediate and uncommon success. Wyeth's first sale was a cover for *The Saturday Evening Post* in 1902; the painting was called *Bronco Buster,* derived from his experience as a sometime cowhand, and for the rest of his professional life the West would provide him with some of his most rewarding subjects. As with *The Lee of the Grub-Wagon,* he managed to blend the broad, muscular, almost caricaturelike style that was his trademark with an uncanny sense of verisimilitude. You can almost hear the conversation among the cowhands hunkered down here for their morning meal, the grub-wagon behind them providing both shelter from the wind and a kind of mobile community center.

The *Post* and all its sister publications—chief among them *McClure's, Collier's, Scribner's,* and *Everybody's*—as well as book publishers putting out everything from the tales of Robert Louis Stevenson to new editions of *The Virginian* gave Wyeth plenty of opportunities to paint. He was extraordinarily productive. Between the first of May and the first of September, 1916, for example, he churned out twenty-eight book illustrations, two magazine stories for *Scribner's,* several for *Collier's,* one formal portrait, and an advertising picture for the Pierce-Arrow automobile. Advertising, in fact, remained a mainstay of his work, as it did for most illustrators of that day (and our own, for that matter), and the most famous of all were two illustrations for Cream of Wheat in 1907 that depicted western scenes. Both appeared in the product's magazine advertisements for many years, acquiring a kind of national audience. The first image showed a cowboy on a bucking horse kicking up a good deal of dust and action; the more durable painting had a cowboy putting a letter in a mailbox made out of an old Cream of Wheat carton. "Where the Mail Goes," the advertisement sang, "Cream of Wheat Goes."

Oil on canvas.
38 × 26 in.
Buffalo Billl Historical Center,
Cody, Wyoming. Gift of John M. Schiff.

Frank Tenney Johnson
1874–1939

A Morning Shower

1927

◆•◆•◆•◆

Frank Tenney Johnson was born in 1874 in Iowa, and ran away from home at the age of fourteen, apprenticing himself to a painter of panoramas—long scenes that were slowly unrolled before an audience like a primitive form of motion picture. Later, he managed to acquire some formal training with William Merritt Chase and Robert Henri in New York, but he did not really begin to develop his own distinctive style until *Field and Stream* magazine sent him to the Rockies and the Southwest as an illustrator in 1904.

Like most artists introduced to the far West, Johnson fell in love with it immediately. He moved to Colorado, then after several years to California, where his work became popular enough to support him without his having to depend on magazine assignments. There, in Los Angeles, he founded the Biltmore Art Gallery. He still loved western subjects, and in *A Morning Shower,* which appeared on the dust jacket of Clarence E. Mulford's 1927 western novel, *Hopalong Cassidy,* Johnson captured an uncommon moment of quiet reflection against the kind of eloquent western skyscape for which the artist became most famous.

Johnson's cowboy, quietly smoking in the morning light, suggests something particular about the breed. There wasn't much "paw and beller" to a proper cowhand, who was not ordinarily given to expressing his innermost thoughts to his bunkmates late at night. Which is not to say that he did not have such thoughts. He did; if he had not had them, there would not have been such a plethora of range-built poetry and song produced over the years, much of it revealing considerable sensitivity as well as outsized humor. There was much to reflect on. Death was commonplace in the cowhand's life—if not his own or that of his companions, then that of the animals he made his living tending. As Owen Ulph, himself a cowhand in the 1950s, has written in *The Fiddleback*: "Watching cattle sink helplessly into quicksand, or plunge to destruction over rimrock, or 'die up' during blizzards, or drown while swimming rivers was a significant feature of the cowboy's job. These experiences were far from colorful to the cowboy. . . . If he did not brood over them, he reflected on them privately, and they shaped his philosophical attitudes."

Oil on canvas.
36 × 28 in.
The Rockwell Museum, Corning, New York.

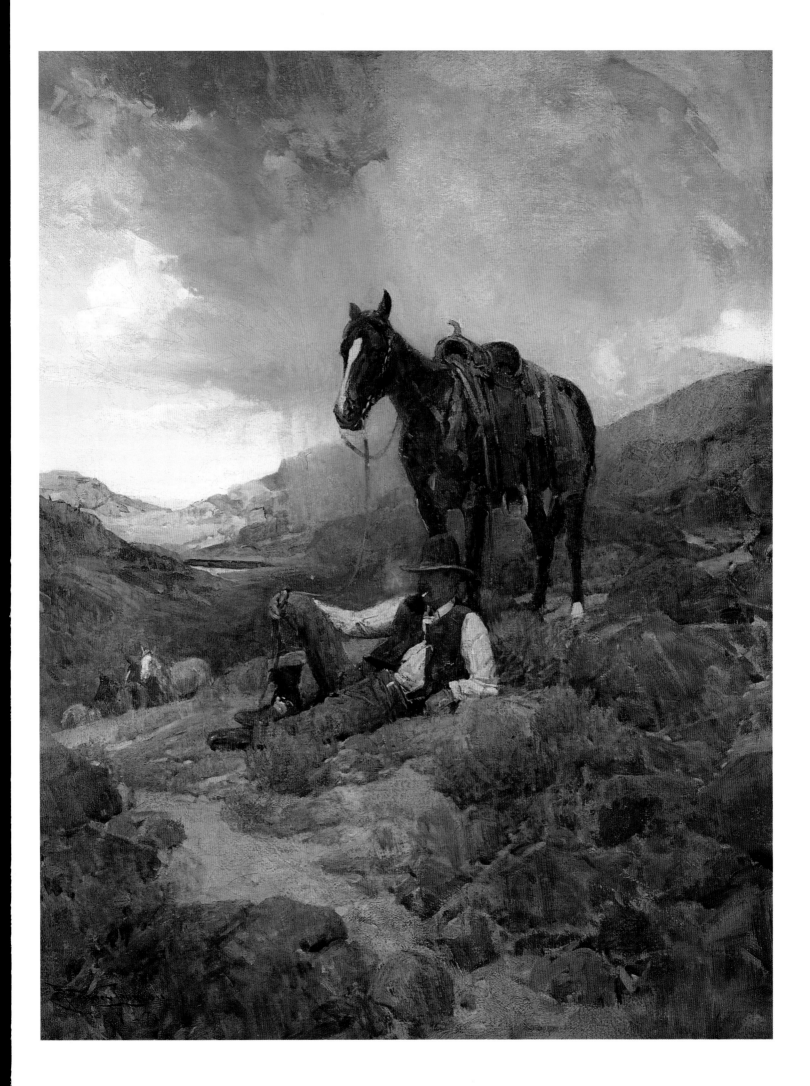

W.H.D. Koerner
1879–1938

Hard Winter

1932

◆•◆•◆•◆

Wintering a cattle herd on the blizzard-ridden High Plains was never an easy matter, as Koerner's wonderfully expressive *Hard Winter* demonstrates with a certain clarity. Even today, while they are more often driving in pickup trucks than sitting on a tail-tucked horse, ranchers spend much of their time hauling seed-cakes or hay bales out to cattle that would otherwise starve during the winter months because they cannot paw their way through crusted snow to get at the grass beneath.

There has never been a winter quite like that of 1886–1887, however, and it still stands in historical memory as a cautionary tale revealing the perils to cows and industry alike when the land is abused. For several years in a row in the 1880s, the range cattle industry had blossomed. Prices were good and profits were high, and even foreign investors got in on the action. Tens of thousands of cattle were put on the grasslands of the High Plains to fatten for market — too many thousands. The land was brutally overgrazed by the summer of 1886, and it would have been hard to keep many cattle healthy on it even if there had not come a severe drought that left even unabused grassland parched and dying.

Then came the winter, the worst in memory. Day after day, week after week, the snow fell, filling ravines and coulees to the top, leaving nothing but mountains of snow so deep the cattle could get nowhere near the grass and human rescuers nowhere near the cattle. The cows, moving with the wind at their backs, jammed into fence corners and piled up there until they froze to death. "The starving cattle died by scores of thousands before their helpless owners' eyes," Theodore Roosevelt, whose own western ranch was devastated, remembered. "The bulls, the cows who were suckling calves, or who were heavy with calf, the weak cattle that had just been driven up the trail, and the late calves suffered most."

It is still called the "Big Die-Up."

Oil on canvas.
29 × 41 ⅛ in.
Buffalo Bill Historical Center,
Cody, Wyoming.

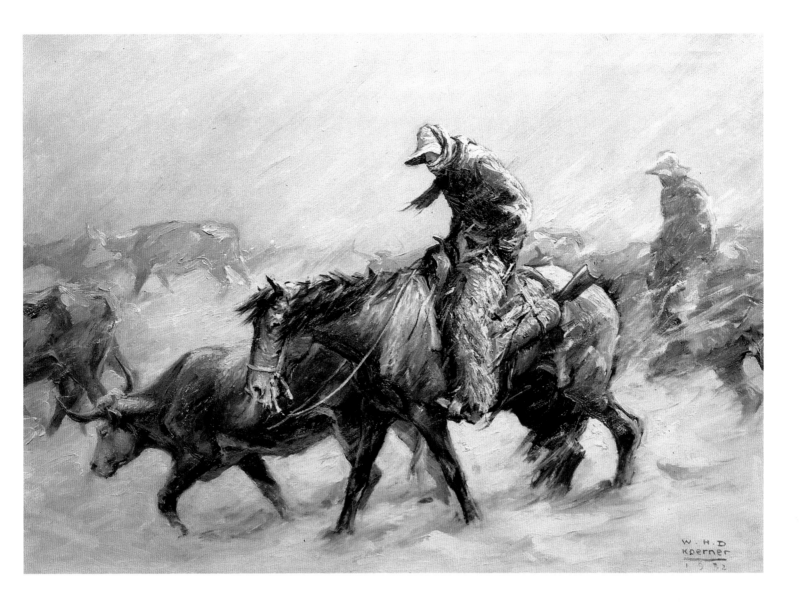

Olaf C. Seltzer
1877–1957

The Faro Layout in the Mint Saloon
1934

◆•◆•◆•◆

Olaf Carl Seltzer was born in Copenhagen, Denmark, in 1877 and emigrated to this country in 1892. Like many foreigners (including a startling number of artists), he was fascinated by the West and moved to Great Falls, Montana, where he worked as a machinist for the Great Northern Railroad. He also befriended Charles M. Russell during the years in which Russell still lived in Great Falls. In the 1930s, Seltzer was commissioned to produce a series of paintings depicting the history of Montana. *The Faro Layout in the Mint Saloon* is from this series.

The Mint Saloon was a Great Falls institution even when Seltzer knew it in the 1890s. Its faro game, like gambling opportunities in cowtowns all over the West, was, of course, designed to separate the cowboy from his season's wages. "Like most of the boys of the early days," one old hand recalled, "I had to sow my wild oats, and I regret to say that I also sowed all of the money I made right along with the oats."

Charles Russell knew the Mint even better than Seltzer. In fact, the indistinct paintings seen on the walls in Seltzer's work may well have *been* Russell's. In the years before Russell sobered up and became famous, the former cowboy's thirst often exceeded his cash, and he was in the habit of trading pictures for drinks. Newspaperman William Ellsberg once wandered into the Mint for the first time as a young man and was struck by the art he saw hanging there. "The action and color were so vivid and lifelike," he remembered, "that they seemed to breathe and move. Mesmerized, I strolled from one to another. Then to my new friends, with all the assurance of eighteen-year-old authority, I pronounced the artist who had painted them a genius."

"Nah," scoffed one cowboy at the bar. "I seen lots better."

The critic, Ellsberg later learned, was Russell himself.

Oil on board.
4 ¼ × 6 ¼ in.
From the Collection of the Gilcrease Museum, Tulsa, Oklahoma.

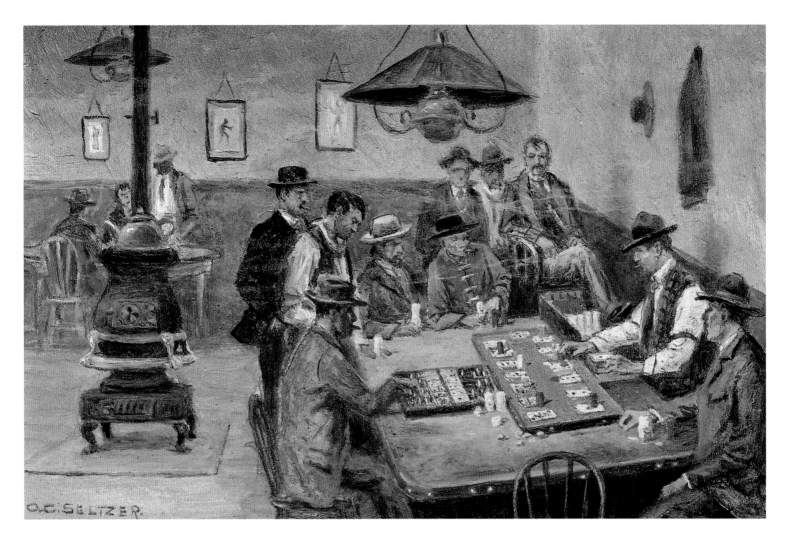

Ila Mae McAfee
b. 1900

Longhorns Watering on Cattle Drive

20th century

◆·◆·◆·◆

Like Charlie Russell, Ila Mae McAfee was among the first of the truly western artists—having been born in the West (in Gunnison, Colorado), first trained in the West (at the Colorado State Normal School), and, after studying mural painting with James E. McBurney in Chicago, moving to Taos, New Mexico, in 1926, where she became best known for her depiction of horses, cattle, and sundry wild creatures.

Her undated *Longhorns Watering on Cattle Drive* exemplifies that particular skill, but also captures an important moment in a purely western phenomenon that, like longhorn cattle themselves, has since almost vanished from the scene: the cattle drive. The drama she conveys here (nicely alleviated by the comic encounter between a cow and a skunk on the bank of the river) was real enough, for the cattle drives that were the essential elements in the rise of the livestock industry after the Civil War were of great length and involved thousands of cattle and scores of riders.

Texas was full of unsold cattle after the war. One cattle buyer from Iowa in 1866 described the land along the Brazos River as being "literally covered with tens of thousands of cattle, horses, and mules." In order to be sold, the animals had to be rounded up and headed north to the railroads that terminated at towns west of the Missouri River in Kansas—towns like Abilene, Dodge City, Ellsworth, Wichita, and Caldwell being the most important. Beginning in 1866, as many as 260,000 half-wild and nearly uncontrollable Texas longhorns were driven from Texas to Kansas, the drovers fording rivers and fighting off Indians and trespassing on farmland all the way. Between 1866 and 1885 an estimated total of 5.7 million head of cattle made it either to the railheads in Kansas or all the way up to the rich grasslands of Wyoming and Montana, where they would be fattened up to increase their value before being driven once again to shipping points for the eastern markets, especially Chicago.

While it lasted, cattle driving was an extremely profitable business. In 1865, Chicago's Union Stockyards opened, and in 1869 its directors could celebrate the wisdom of the move. The "importation of Texas cattle," they wrote, "is an immense business and continually growing, and with the extension of the railroads through Kansas, and south into Texas, no one can compute the number of cattle in that section that will seek a market in Chicago. The People, and especially the consumers, demand this Texas stock, as it lessens to them the price of beef. . . ."

Oil on canvas.
21 1/2 × 37 3/4 in.
From the Collection of the Gilcrease Museum, Tulsa, Oklahoma.

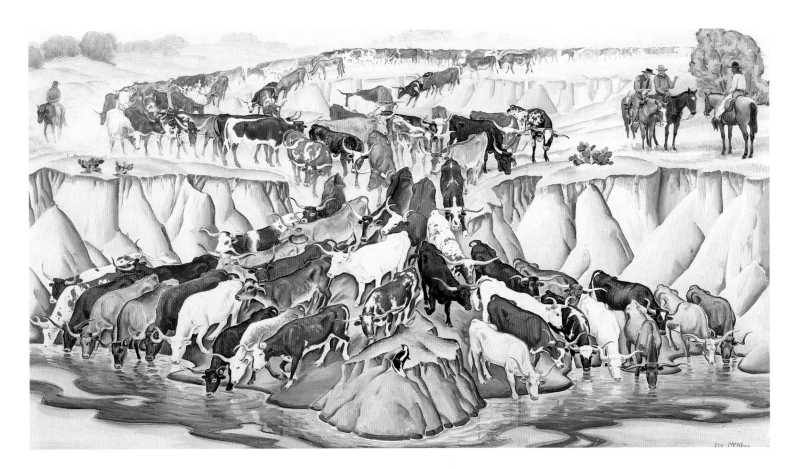

John Sloan
1871–1951

Chama Running Red
1925

◆•◆•◆•◆

In spite of the rider he put into this view of the Chama River in New Mexico— colored by spring runoff from the Sangre de Cristo Mountains—John French Sloan could not by any stretch of the imagination be called a "cowboy" artist. He got his start as a newspaper illustrator for the *Philadelphia Press,* where he produced hundreds of news drawings and Sunday illustrations while learning to create more serious work in the evenings. In 1904 he moved to New York City, where he emerged as probably the best known member of the band of artists who became known as the "Ashcan School" in the years before World War I. For much of his career, then, he was given more to gritty urban scenes designed to reveal the unadorned reality of life as it was seen and experienced by those more accustomed to riding subways and ferries than horses.

But in 1919, Sloan, like so many postwar American artists, went on a pilgrimage to New Mexico and—again like virtually all artists—became entranced with the people and the place. For most of the rest of his life, he spent at least four months of every year living in or around Santa Fe. Even here, much of his best work depicted people at work and play in Santa Fe and in nearby Pueblo Indian communities, where he documented festivals, everyday scenes, and other aspects of life in the narrow streets and plazas and piled-up adobe complexes of the region with much the same flair (if a good deal less of the grit) he had brought to the ash-cans and alleyways of Manhattan.

Still, the artist could not escape the light and colors of the landscape, nor did he want to. "I like to paint the landscape in the Southwest," he wrote, "because of the fine geometrical formations and the handsome color. . . . I like the colors out there. . . . When you see a green tree it is like a lettuce against the earth, a precious growing thing. Because the air is so clear you feel the reality of things in the distance."

Oil on canvas.
30 1/4 × 40 1/4 in.
Courtesy of The Anschutz
Collection, Denver, Colorado.

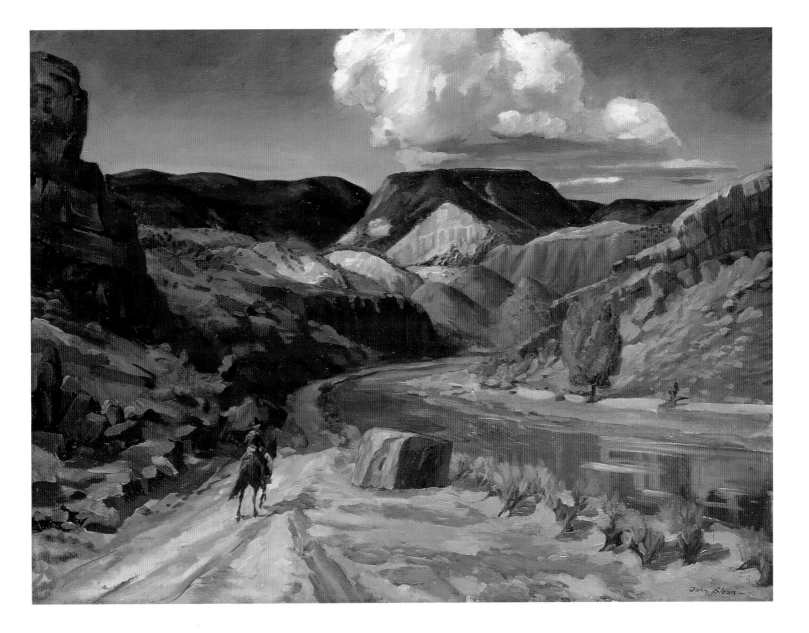

David Halbach
b. 1931

Headin' Out

c. 1993

◆•◆•◆•◆

That the lifestyle of the cowboy still has a powerful hold on our memory is superbly illustrated by David Halbach's luminous early-morning scene, *Headin' Out*. There is no apparent attempt here to romanticize the moment; the men are ordinary cowhands and there is work to be done, much of it in deep mud left in the wake of a heavy storm that has passed through. They will have to gather up cattle that the storm has scattered from hell to breakfast. They probably will find cows or calves wallowing helplessly in mud up to their bellies and will have to pull them out—or even get down into the muck themselves to help shove them out, as dangerous a job as it is filthy. There may be a few carcasses left in the wake of flash floods and calves for which nurse cows willing to take them will have to be found. In short, chores to do and miles to ride before they can bed down—probably on the still-damp ground in a sleeping roll.

No romance, then. Nevertheless, with the blush of morning light on the distant hills and the clarity of a cloudless sky washed even cleaner than usual by the storm, and by the subtle sense of anticipation in the tension of the cowboys as they wait for their bunkmates to get their gear together, there is a kind of quiet excitement in the scene—the inchoate feeling of freedom and possibility that often characterizes mornings in the West when you know you are going to be spending your time out in the country. "Much of the time," former cowhand Owen Ulph remembered, "was spent in the high country where we drank clear, cold 'sweetwater,' where a smooth silken breeze swept lightly from the thinly wooded hills setting the clusters of aspen shimmering and freshening every afternoon. Nights were always cool. Sleep was a pleasant, dream-free coma that eased the aches and stiffness from the body. Appetites were keen and the simplest pleasures were given a fine edge by the life of severe contrasts."

If that was romance, it owed more to circumstance than to fantasy.

Watercolor.
18 × 29 ½ in.
Private collection. Courtesy of the artist.

74

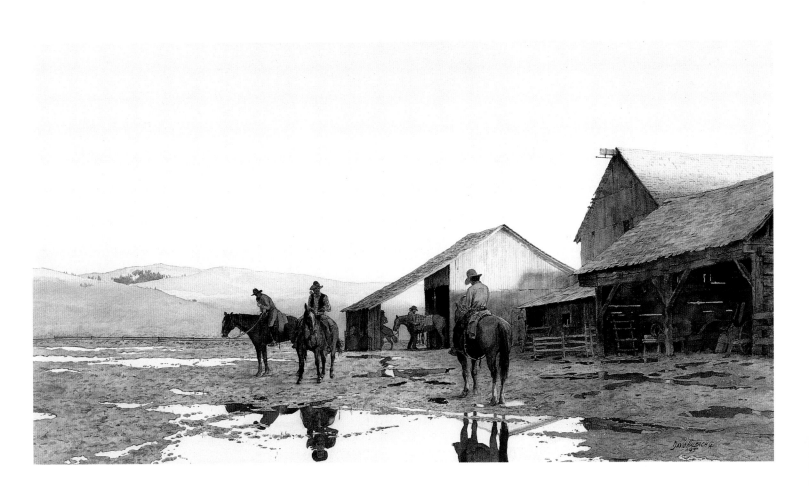

Fletcher Martin
1904–1979

July 4th, 5th, and 6th
1940

◆·◆·◆·◆

On a fenced racetrack in the 1860s, Buffalo Bill Cody proposed to demonstrate his skills as a hunter of buffalo for the Union Pacific Railroad. He borrowed a small private herd of surviving buffalo, armed his rifle with blanks, and sent out handbills inviting cowboys to compete in an "Old Glory Blow-Out," with bronco-busting, roping, shooting, and riding events for donated prizes. He hoped for a dozen replies and got a thousand, and the Glorious Fourth celebration that resulted has been called the beginning of both the Wild West show and the rodeo—to this day, a major part of the Fourth of July in most self-respecting Western county seats.

In fact, rodeo had its beginnings in the early cattle roundups, with their showoff and byplay. As early as 1847, a Santa Fe roundup was described as "a great time for the cowhands, a Donnybrook fair. . . . They contest with each other for the best roping and throwing, and there are horse races and whiskey and wine . . . and there is much dancing in the street." As the range cattle industry declined, the impromptu celebrations of roundup time gradually evolved into the complex, highly professionalized, and monetarily rewarding rodeo that we know today.

In *July 4th, 5th, and 6th,* Fletcher Martin has painted two of the bravest of rodeo performers at work—the steer wrestler taking his animal to the ground, and the clown in the foreground, whose task is to distract the animal and keep him from going after the steer wrestler once the ritual is done. Martin — printer, lumberjack, harvest hand, sailor, and self-taught painter — became a full-time artist during the Great Depression, when he was chosen to paint a federal mural, and spent the rest of the 1930s exhibiting and teaching. The stylized, linear treatment that captures the speed and excitement of the rodeo here became his "signature." That same style served him well during World War II, when he served as an artist-correspondent for *Life* magazine. After the war, he returned to teaching, commercial art, and illustration until his death in Mexico.

Oil on canvas.
40 × 55 in.
Courtesy of The Anschutz
Collection, Denver, Colorado.

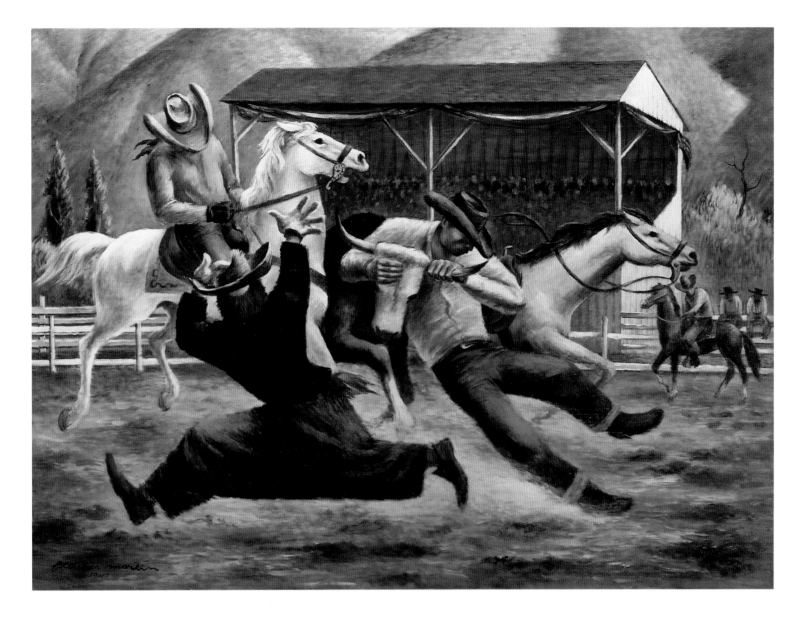

Delmas Howe
b. 1935

Apollo's Half-Acre
1991

◆•◆•◆•◆

If David Halbach and other contemporary western painters continue to echo the work of the best "cowboy" artists of the nineteenth and early twentieth centuries, limning the cowhand's life in generally traditional forms, others have found allegory and even satire more to their liking—some of it less subtle than energetic and sometimes wonderfully humorous. Such is Delmas Howe of New Mexico, who has decided to take the tattered myth of the cowboy and raise it to another level in a series of near-satiric paintings in which the figures are presented as various ancient deities—gods with their boots on.

Born in El Paso, Texas, but raised in Truth or Consequences, New Mexico, Howe was educated at Yale and trained in his art both there and at the Art Students League and the School of Visual Arts. He was a designer and muralist in New York City before moving back home. "Having been raised in Truth or Consequences," he has said, "my return here creates conflicting emotions; these feelings are reflected in my art. The juxtaposition of cowboy iconography against ancient gods and heroes is a way of exploring both my own roots and urban American and European cultures."

One of the most successful in this series is *Apollo's Half-Acre*. Apollo was the Greek god of light, a kind of sun-god (though not the sun itself) and a prophesier whose duties included making the fruits of the earth ripen and keeping watch over flocks. In Greece, of course, the flocks would have been sheep. In New Mexico, for the most part, they would be cattle, and in *Apollo's Half-Acre* the artist may well be making a comment not merely on the bloated mythology of the cowboy himself—making him more caricature than icon—but on what his industry has managed to do to the Southwestern land over the past couple of centuries. The half-acre that "Apollo" is surveying with one hip cocked nonchalantly is rutted with gullies and almost certainly overgrazed.

Howe is one of the many talented people in New Mexico who carry on the legacy of the region's first generation of twentieth-century artists. The artistic community includes many Native American and Hispanic artists—including Allan Houser, Bernadette Vigil, Darren Vigil Gray, R.C. Gorman, Margaret Nes, and Elias Rivera—whose work has become of increasing importance.

Oil on canvas.
68 × 59 in.
Courtesy of Copeland Rutherford Fine Arts Ltd., Santa Fe, New Mexico.

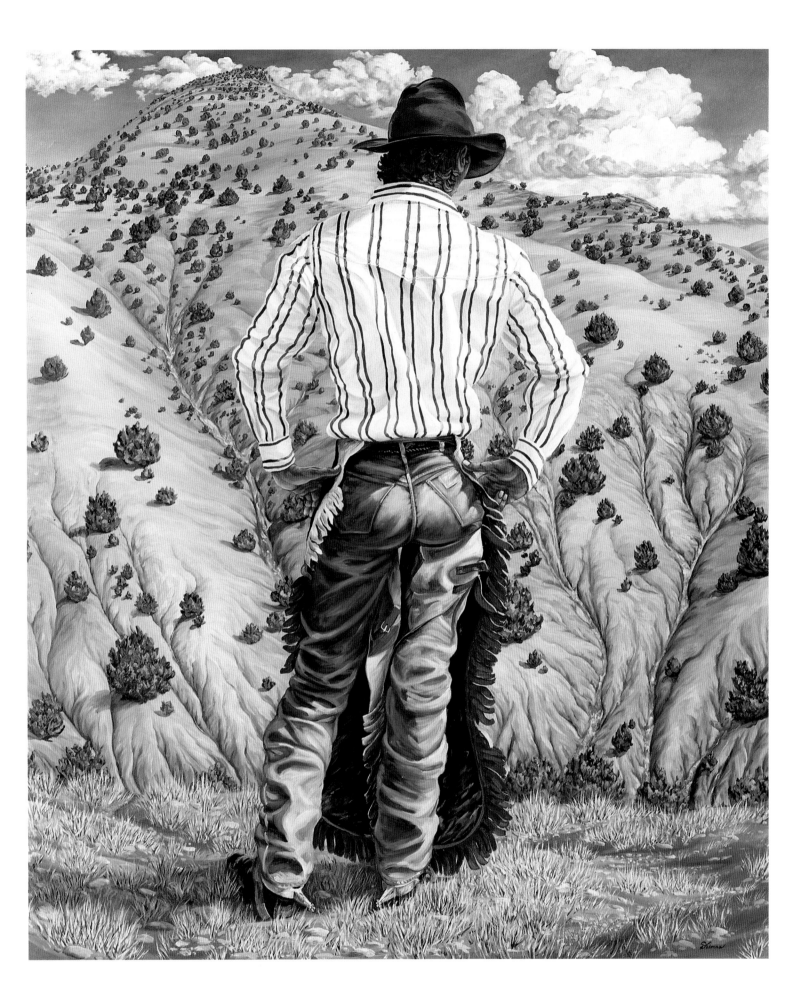

Annie Oakley: The Peerless Wing and Rifle Shot

1898

◆•◆•◆•◆

When the great leader Sitting Bull first saw the slight young woman shoot in exhibition in 1884, he called her "*watanya cicilia*"—"Little Sure Shot." Though she was born Phoebe Ann Moses in 1860 in Darke County, Ohio, it was as "Annie Oakley" that she became a worldwide Western legend.

Annie Oakley had learned to shoot at eight and later helped support her family by supplying game to a Cincinnati hotel. Its owner arranged a match for her with Frank Butler, a touring sharpshooter. She beat him at the match and at age sixteen she married him. The Butlers joined Buffalo Bill Cody's Wild West show in 1884 and toured with it for almost seventeen years. Becoming world famous during Buffalo Bill's London performances for Queen Victoria's Golden Jubilee in 1887, Annie Oakley later toured Europe solo, joined Pawnee Bill's Wild West troupe, and starred in a Western melodrama before rejoining Cody in 1889.

Annie Oakley was "personality in movement," and her repertoire was breathtaking. She could shoot a dime from her husband's fingers or a cigarette from his mouth. She riddled cards with direct hits, and a pass punched full of holes for identification became known as an "Annie Oakley." With a shotgun during one nine-hour competition she hit 4,772 out of 5,000 glass balls thrown in the air. Offstage she was quiet and did needlework between shows.

This poster celebrates "the peerless wing and rifle shot": She shoots from a horse and a bicycle; she brings down running deer and flying quail; she hits hand-held cards and airborne balls; she wings both real and clay pigeons; and she performs right through a blizzard. In every challenge she keeps her hat on straight.

In 1901 Annie Oakley was badly hurt in a train wreck; her skill returned but not her former vitality. During World War I the Butlers visited Army camps giving instructions and exhibitions. In 1921 she went home to Ohio where she died in 1926. Her husband died less than a month later.

Poster. Lithograph on paper.
40 × 30 in.
Circus World Museum, Baraboo,
Wisconsin.

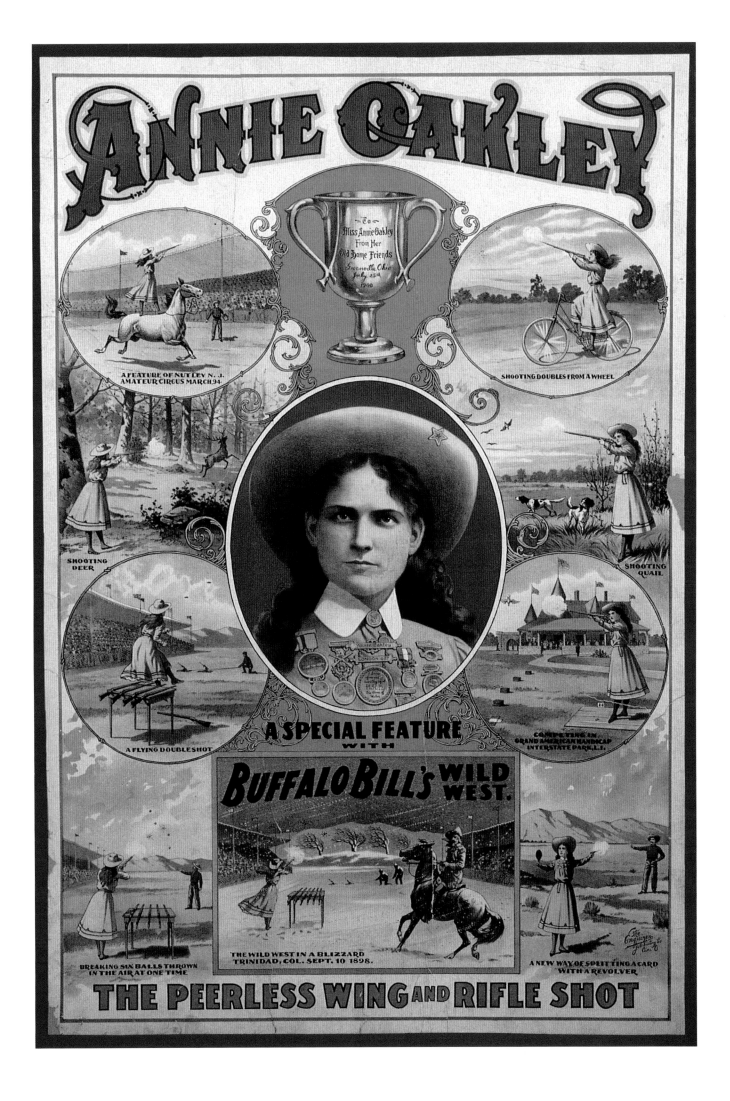

Rosa Bonheur
1822–1899

Col. William F. Cody

1889

◆·◆·●·◆

William Frederick ("Buffalo Bill") Cody, a real player in the frontier life he became famous for romanticizing, lived a life to match his legends. He was one of the young men "willing to risk death daily" for the Pony Express. During the Civil War, he rode with the Seventh Kansas Volunteer Cavalry and later earned his nickname by shooting buffalo to provide meat for the crews building the Union Pacific's segment of the transcontinental railroad.

From 1868 to 1872, Cody scouted for the Fifth U. S. Cavalry, and as an Indian fighter was cited for his extraordinary tracking and fighting skills. In an 1876 skirmish he killed warrior chief Yellow Hand and in doing so took what was called "the first scalp for Custer." (Custer's Seventh Cavalry had been destroyed earlier that year.) As a hunting guide, Cody worked for everyone from scions of European royalty to writer Ned Buntline, who made him the hero of several of his "dime" novels. Buntline also launched Cody's ten-year career on the stage in Western melodramas.

But it was as a great American entertainment entrepreneur—producer and star of Buffalo Bill's Wild West—that he became well known internationally. The show had everything: Pony Express riders, attacks on a stagecoach, bucking broncos, wild steer roping and riding, a little herd of captive buffalo, elk, wild mustangs, Texas longhorns—as well as Sioux Chief Sitting Bull and "Little Sure Shot," Annie Oakley.

In 1887 Buffalo Bill and Company gave command performances in London for Queen Victoria's Golden Jubilee. In 1889 the show played near Paris for seven months. Rosa Bonheur, a celebrated French painter and sculptor of animals, had been the first woman to receive the Legion of Honor in an age when female artists were barely recognized. Bonheur, then sixty-seven, visited Cody's thirty-acre encampment every day to sketch the Indians and the menagerie, and painted from these studies for the rest of her life. This painting of the showman became one of Bonheur's most famous and was widely reproduced. Cody sent it to his wife in Nebraska, and later, when he heard his house was on fire, reportedly wired: "Save the Rosa Bonheur and let the flames take the rest."

Oil on canvas.
18 ½ × 15 ¼ in.
Buffalo Bill Historical Center, Cody, Wyoming. Given in memory of William R. Coe and Mai Rogers Coe.

82

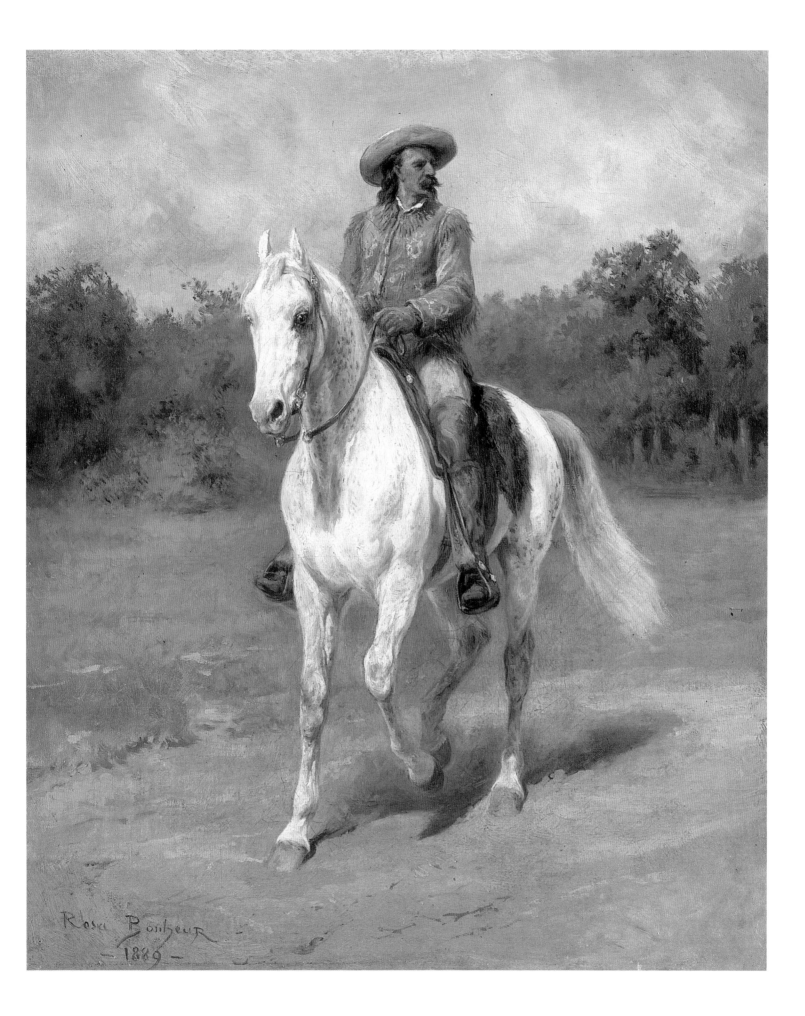

Rosa Bonheur
- 1889 -

Bill Pickett: "The Bull-Dogger"

1923

◆•◆•◆•◆

The biggest star of the Miller Brothers 101 Ranch Real Wild West Show—last of the entertainment form begun by Buffalo Bill Cody in the 1880s—was Bill Pickett, the Texas cowboy son of former slaves. Born in 1862, Pickett was one of numerous black cowboys employed in cattle country in the post–Civil War generation, when as many as one quarter of the cowhands working the long drives were African-American or Mexican-American. "Perhaps the most important rodeo figure of all time," as one historian has called him, Pickett earned his place in the Rodeo Hall of Fame by creating a daring showstopper of an event. It was called "bulldogging," later known as steer wrestling. Aboard his horse Spradley, Pickett would ride alongside a running steer and then leap to the ground. Literally grabbing the bull by the horns, he would twist the animal's head up and seize its upper lip in his teeth, hitting a nerve which stunned the animal, allowing Pickett to wrestle the bull to the ground. Pickett learned this technique from watching his dog Spike herd cattle. In later years, less adventurous steer wrestlers dropped the practice.

Small and wiry, Pickett became a cowhand when he was ten. He later starred in rodeos throughout America, Canada, Mexico, South America, and Europe, and in 1912 as the "Dusky Demon" gave four hundred performances. Both Tom Mix and Will Rogers began as his assistants. At the ranch or in the arena, Pickett was treated royally, but once outside it was a different story. He was refused service in white restaurants and white hotels, and when traveling by train had to ride with the animals.

In 1923, as this poster indicates, he starred in "The Bull-Dogger," a black-audience movie produced by the Norman Film Manufacturing Company. Pickett died in 1932, at age seventy, stomped to death by a maverick pony while working horses at the 101 Ranch in Oklahoma. In 1994, the rodeo star was honored as one of the "Legends of the West" with a commemorative U. S. postage stamp, but his brother Ben's picture was mistakenly used, an error that has made that issue a sought-after collector's item. A later edition features the right Pickett.

Poster. Lithograph on paper.
40 × 30 in.
Archive Photo.

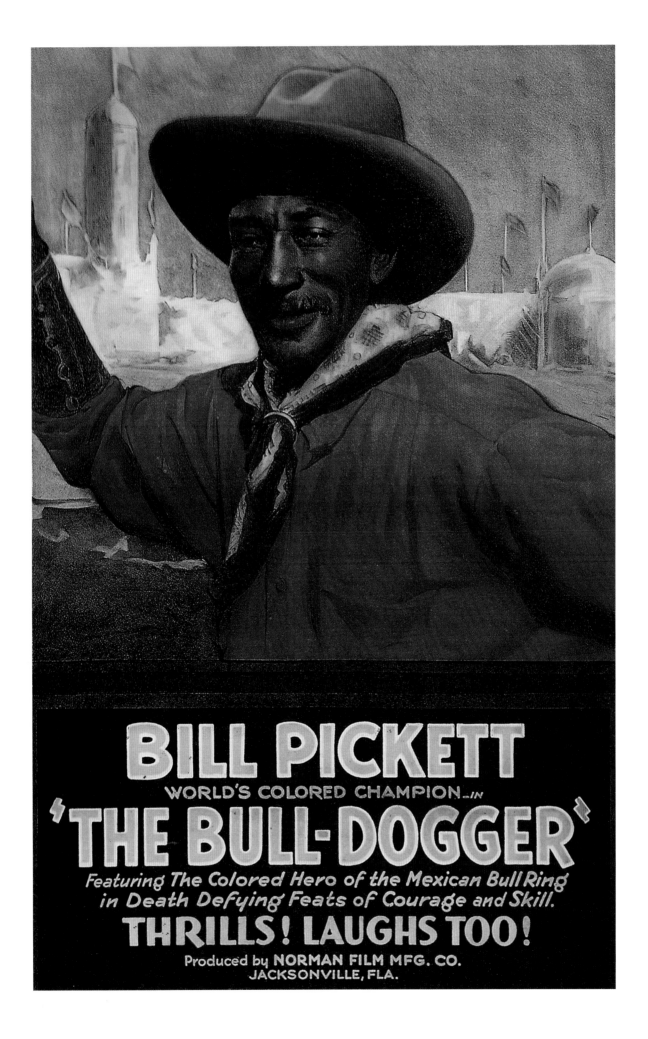

Fred Kabotie
1900–1986

Hopi Tashaf Kachina Dance

1946

◆•◆•◆•◆

Some of the most moving rites among the Hopi people of the Southwest are the kachina, or katsina, ceremonies, when participants adorn themselves in the regalia of ancestral spirits to sing and dance, while the people of the pueblo gather on the rooftops to watch the proceedings. In this scene, painted by Hopi artist Fred Kabotie, the kachina dancers seen in the plaza of the pueblo are taunted by a group of koshare, or sacred clowns, part of the complex weave of ritual that holds the Hopi world together.

It was the katsinas themselves that spoke to Kabotie as a homesick child taken from his parents and placed in the Santa Fe Indian School for teaching shortly after the turn of the century. He was fortunate to have teachers who encouraged him to develop his talent. "Naturally I painted what I missed out here," he remembered. "My life." Not landscapes, he emphasized: "The Hopi don't paint landscapes, they have no color for that. . . . I had been away so long then that I was yearning . . . getting lonesome for my Hopi way, and I started painting katsinas, because I missed them. . . ." That yearning spawned a career that made Kabotie one of the most widely known and respected of all Native American artists.

Much of the ceremony of the kachina dances has to do with the ancient need to propitiate the spirits to assure one's survival in a harsh land. This is not always fully understood by Anglos, even anthropologist Anglos. A story in Peter Nabokov's *Native American Testimony* tells of one such individual who asked a Hopi elder what one of the songs meant. "Well," the old man replied, "that's about when the kachinas came down into the mountains and then the thunderheads build up around the San Francisco peaks and then we sing and those clouds come out across the desert and it rains on the gardens and we have food for our children."

After hearing several Hopi songs about rain and water—critical needs of the Hopi—the anthropologist mused about such a subject for song, as compared to the subject of love that serves as the basis for much American music.

"Is that because you don't have very much?" the Hopi wondered.

Watercolor on paper.
18 1/2 × 22 1/8 in.
Philbrook Museum of Art, Tulsa, Oklahoma.

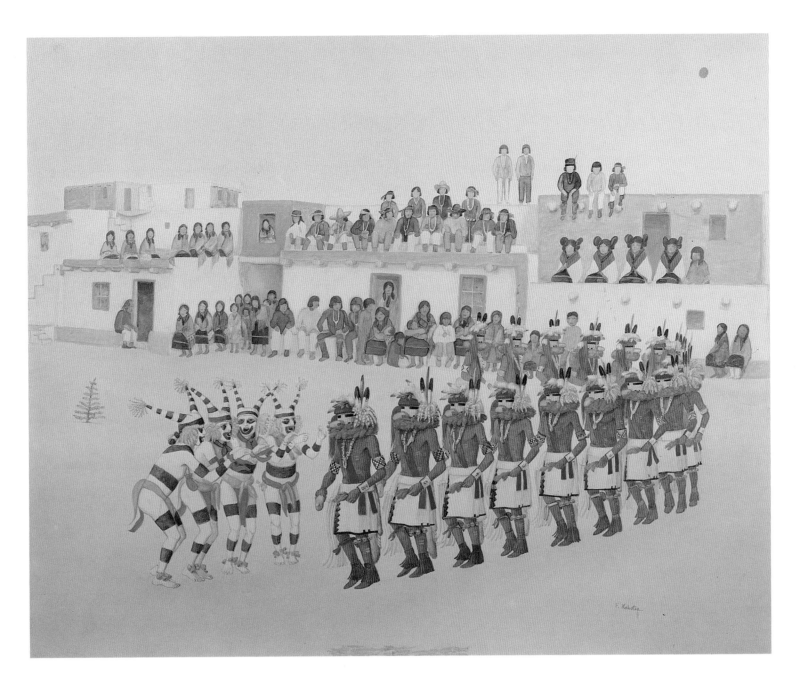

Jaune Quick-to-See Smith
b. 1940

Buffalo

1992

We are near the heart of the buffalo region," newspaper publisher Horace Greeley excitedly told the readers of his *New York Tribune* in 1859. He was in the middle of his famous transcontinental stagecoach journey and had just encountered the definitive animal of the Great Plains—the American buffalo. "The stages from the west . . . report the sight of millions within the last two days. Their trails checker the prairie in every direction. A Company of Pike's Peakers killed thirteen near this point a few days since. Eight were killed yesterday at the next station west of this by simply stampeding a herd and driving them over a high creek bank where so many broke their necks. . . . I do not like the flesh of this wild ox. . . . I would much rather see an immense herd of buffalo on the prairie than eat the best of them. . . ."

They were indeed impressive. Adult males stood seven feet tall at the shoulder and weighed about a ton. Females averaged five feet high and weighed anywhere from seven hundred to eight hundred pounds. Even in the 1850s, there were still enough buffalo that in some areas during their constant migration north and south across the Plains they covered the land like a shaggy, moving carpet of life. Stampeding, they sounded like thunder. In less than thirty years, almost all of them were gone. Millions were killed by professional hunters who sold their rough coats to eastern tanners. Game hunters killed them for sport, ate only the tongues or humps, and left the rest to rot—in contrast to the nomadic Plains Indian tribes, who followed the herd, revered the animal, and used every part of it for food, shelter, and clothing. Beginning in the 1860s, the Indian-fighting army encouraged the killing by hunters and waged its own relentless campaign of slaughter: kill a buffalo and you starve an Indian.

Modern painter Jaune Quick-to-See Smith's *Buffalo* is a mere outline, a shadow barely visible on a wall covered with a collage of ironic ephemera: advertising, newspaper clippings, an American flag, a cowboy comic strip, a scrap of map, pictures of vanished animals and Indians—a poignant symbol of a lost way of life. The theme fits the artist. A Native American woman born on Montana's Flathead Reservation, Smith studied in Massachusetts and New Mexico and has been described as an "outspoken advocate" for Indian issues. She is a recognized leader in the contemporary Native American Fine Art Movement, and has founded cooperatives, organized and curated exhibits, written catalogues, and designed several public art projects in the West—all in the hope, she says, that her efforts can "make people see things in a little different way—so the message stays, if only for a moment."

Diptych. Oil, mixed media, collage on canvas.
66 × 96 in.
Collection of Eleanor and Leonard Flomenhaft. Courtesy of Steinbaum Krauss Gallery, New York.

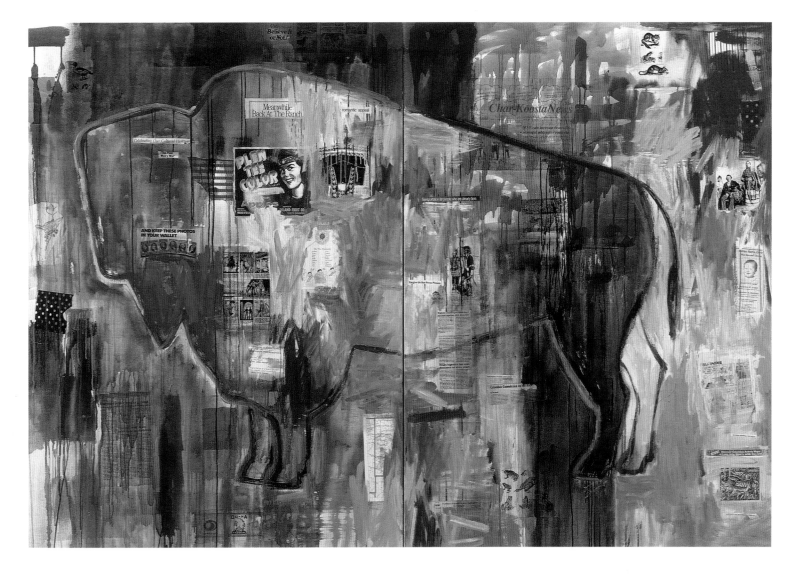

Willard Midgette

1937–1978

"Sitting Bull Returns" at the Drive-In

1976

◆•◆•◆•◆

Like the echo of some Ghost Dance promise from the 1890s—an Indian messiah sent to restore the buffalo and drive out the white man—Sitting Bull returns. Natural leader, chosen chief of all the Teton Sioux, devoted to traditional customs and virtues and the belief that contact with the pale intrusive strangers will weaken and destroy the culture of his people, Sitting Bull dominates the scene as he did in the days of his glory.

But the year is 1976—a hundred years after the Battle of Little Bighorn when "Yellow Hair" Custer and his men were annihilated in the "Battle of the Greasy Grass" (as the Indians called it) in Montana, brought low by their own arrogance and ill luck. Now the tribal lands, the buffalo, and the people—all are gone. The only comeback possible is at a reservation drive-in theatre. In full regalia, Sitting Bull and his men ride proudly on fine horses across the big screen. Their drably dressed descendants shuffle off to their pickup trucks. The contrast could not be more complete—the paradox of contemporary Indian life.

Invited to take part in the *America 1976* bicentennial exhibition, artist Willard Midgette had requested that he be allowed to paint a western subject; he was told to pick an Indian theme. Midgette was invited to spend a few days as artist-in-residence at a Navajo community college in Arizona during the Navajo's annual powwow. He took photographs and returned to Brooklyn to work. Among many paintings of truly heroic scale he produced during that period, *"Sitting Bull Returns" at the Drive-In*—a little over nine feet wide and eleven feet long—almost overwhelms the viewer with the gargantuan contrast between reality and fantasy in the modern Indian world.

Oil on canvas.
108 ¼ × 134 ⅛ in.
National Museum of American Art, Washington, D.C. Gift of Donald B. Anderson.

90

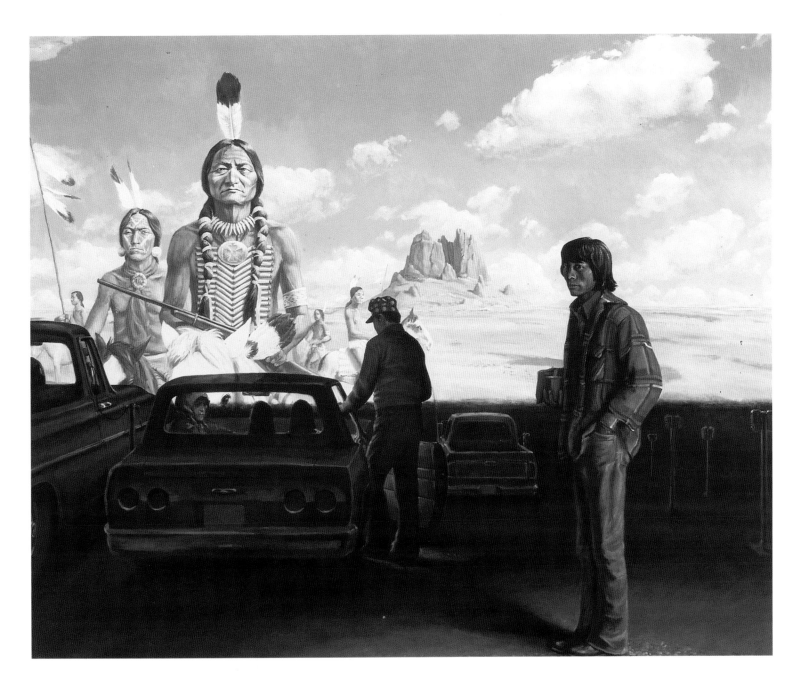

Howling Wolf
c. 1850–1927

Medicine Lodge drawing book, page 3
c. 1875

◆·◆·◆·◆

W hen I hunted the Bufalo I was not poor . . . but here I am poor. I would like to go out on the planes a gain whare I could rome at will and not come back again. . . ."

In 1879, Cheyenne warrior Howling Wolf wrote his thoughts in largely phonetic English in Fort Marion outside St. Augustine, Florida, where he was no longer a buffalo-hunting Indian nomad but a captive from the Indian Wars of the southern Plains. Even as he wrote this complaint, however, the way of life he mourned and yearned for was gone. He had been held in prison for four years. During that period, all the great buffalo herds had been slaughtered, and with their near extinction and the starvation that followed for the Native Americans who relied on the great beast for food and clothing, there was neither need nor energy left for warfare.

Howling Wolf could only relive the past through his art. His jailer, Captain Richard H. Pratt, who later founded the Carlisle Indian School in Pennsylvania (its most famous graduate was athlete Jim Thorpe), encouraged the old warrior and his other Indian charges to capture in pictures the life they had led and lost. In his sketchbook, from which this plate has been reproduced, Howling Wolf drew from memory.

The Sun Dance, held annually, brought the tribe together and was rich in symbol and ceremony. In a troubled time, it was held to honor a vow. "The one who vowed a ceremony," explained one interpreter of Plains Indian ritual, "wanted life or life power and removal of whatever was between him and that life . . . so the ceremony was to bring the life giving power, to make the sick well and promote reproduction not only among the [Cheyenne] themselves but among the animals and plants upon which they mostly depended."

This sketch is of the Medicine Lodge at the beginning of the Sun Dance and shows the grand entry of the medicine men, who are firing—shown by the seven cone-shaped objects near the top of the drawing—at the small rawhide figure hanging from the center pole. Two chiefs ride in on horses, followed by the Soldier Society. Singers and drummers and spectators round out the scene.

Ink and watercolor.
Joslyn Art Museum, Omaha, Nebraska.
Gift of Alexander M. Maish in memory of Anna Bourke Richardson.

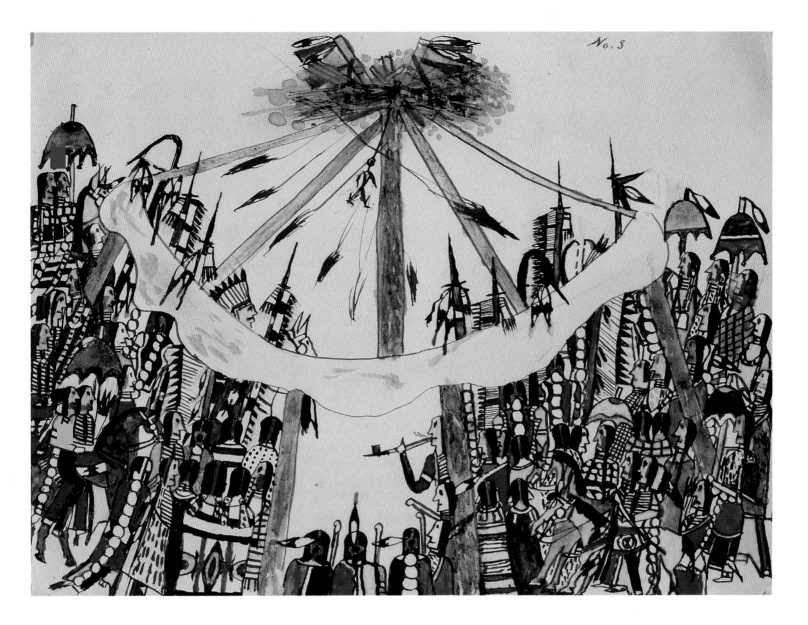

Ada Suina
b. 1930

Storyteller
1988

When the railroad came to Albuquerque in the late nineteenth century, the tourist market came with it. Newly arriving visitors were met at the station by Pueblo potters selling wares, and Anglo and Indian alike enjoyed a mutually beneficial exchange: "souvenirs" of a memorable journey on the one hand and much needed income for the local people on the other. Twentieth-century Native American potters, mostly women, revived the ceramic traditions of their forebears to produce works of art, many now recognized by museums and art collectors for their imaginative blending of historic forms and styles with inventive artistic visions.

In the late 1950s one such artist, Helen Cordero of the Cochiti Pueblo in New Mexico, had been selling bead and leatherwork to tourists. At the suggestion of her grandmother, she gave pottery-making a try; but when Cordero began making ceramic figures, she found her true art.

Cordero soon filled the pueblo with her little pottery people. Figuration, a tradition common to most primitive cultures, which portrayed "outsiders," animals, and singing mothers in ceramic caricature, was a strong Cochiti custom in the twentieth century. Cordero's small birds, animals, and people were seen at a Santo Domingo feast day by a folk art collector, who bought them all and commissioned her to make others. When he encouraged her to make a large seated figure with children, Cordero remembered her grandfather, a highly regarded wise elder who often told stories to children. She created the first "storyteller" in 1964 —a male figure with five grandchildren crowded about him. Cordero's storyteller became a great success, and the many figures that have made up her ceramic family have won numerous local and state prizes and have been widely exhibited at international exhibits and museums.

The popularity of storyteller dolls has endured because of their charm, accessibility, and humor; sometimes the potters incorporate the faces of people they know into the dolls. Today, most storyteller figures are still made at Cochiti Pueblo. Ada Suina, whose obviously well-loved teller of tales is pictured here, first began making storytellers in 1976, and has won many prizes for her impeccable craftsmanship. Her charming figures are characterized by large faces, and have an unusually light orange slip painted on the surface. The one pictured here sings with excitement as the happy children listen with delight.

The artist has taught her four daughters, as well as other Pueblo women, to continue the storyteller tradition.

Clay.
9 × 5 in.
Courtesy of The Amerind Foundation, Inc., Dragoon, Arizona.

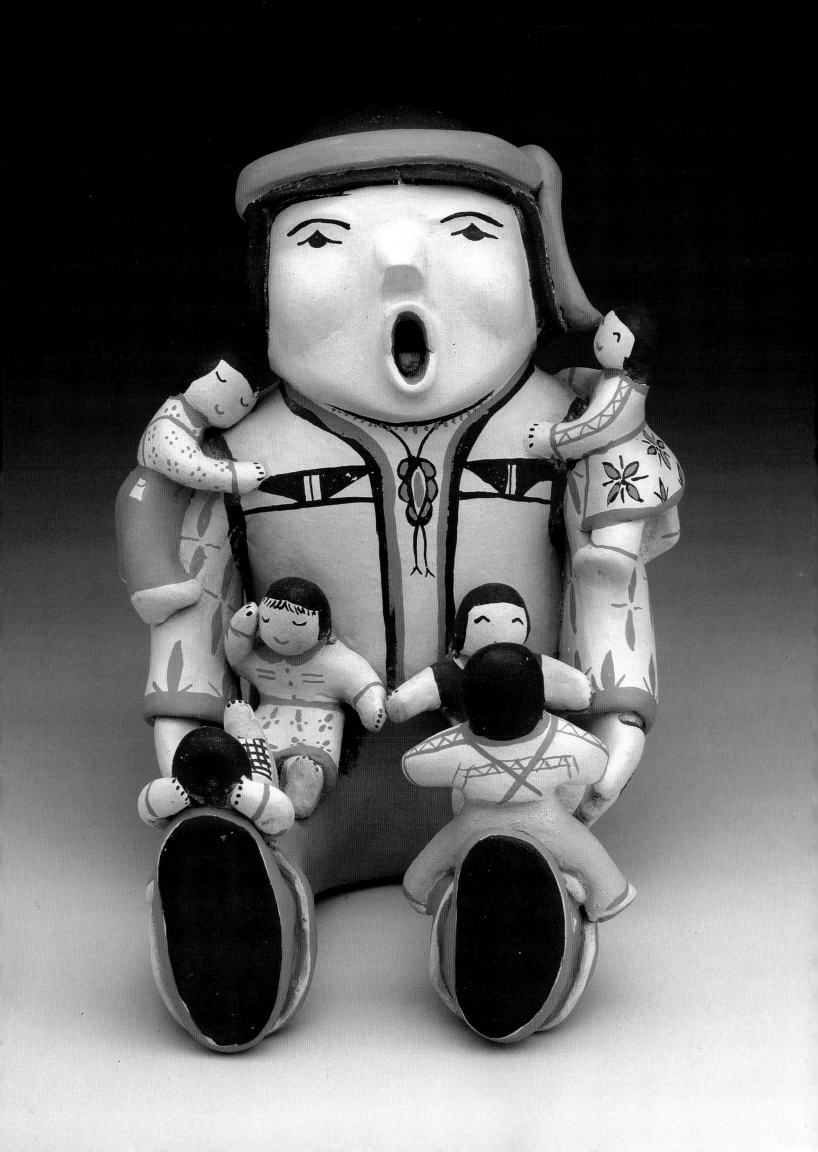

Maynard Dixon
1875–1946

Earth Knower

1931, 1932, 1935

Maynard Dixon was both a painter and poet who loved the great sweeping land of the Southwest better than any other landscape he knew. He illuminated that love in his paintings and documented his understanding in his poetry: "Now I go out alone to ride the free hills/these hills that make no concealment;/where stern and alone I face the thing that I am."

Born in Fresno, California, in 1875, Dixon was proud to be a Westerner. In his professional years, he took to wearing a black Stetson, cowboy boots, a belt of Navajo silver, and sported a cane and Buffalo Bill–style face whiskers. A little theatrical, perhaps, but there was nothing about him that was not legitimately western, according to his friend, photographer and conservationist Ansel Adams, who called him "a free man in a free country."

Dixon's early illustrations for books and magazines were influenced by those of Frederic Remington, but even in the early years of his career he began to move toward greater simplification and spirituality in his work. In 1920 he married Dorothea Lange, later the best known of the New Deal photographers who documented America for the Farm Security Administration during the Dust Bowl years. (Her *Migrant Mother* is the universal icon of the Great Depression's suffering women and children.) The couple's visits to the Navajo and Hopi reservations in the 1920s increased Dixon's appreciation of Indians as "men of the earth," and in 1931, during a six-month stay in Taos, he painted *Earth Knower,* which celebrates the Native American's harmony with space, sun, sky, and earth. *Earth Knower* is an example of what has been called Cubist-Realism, and Dixon-the-painter wrote of it: "The major forms are simplified and reduced to clean geometric patterns of dark and light, yet the realism of the foreground figure is retained."

Dixon-the-poet sang another song, of "the grim gaunt edges of the rocks,/ the great bare backbone of the Earth." Both concepts combined to convey his respect for the Indian and his relationship to the grandeur he inhabited —"the land of room enough and time enough," as his friend Mary Austin put it—Maynard Dixon's West.

Oil on canvas.
40 × 50 in.
Collection of the Oakland Museum, Oakland, California. Bequest of Abilio Reis.

96

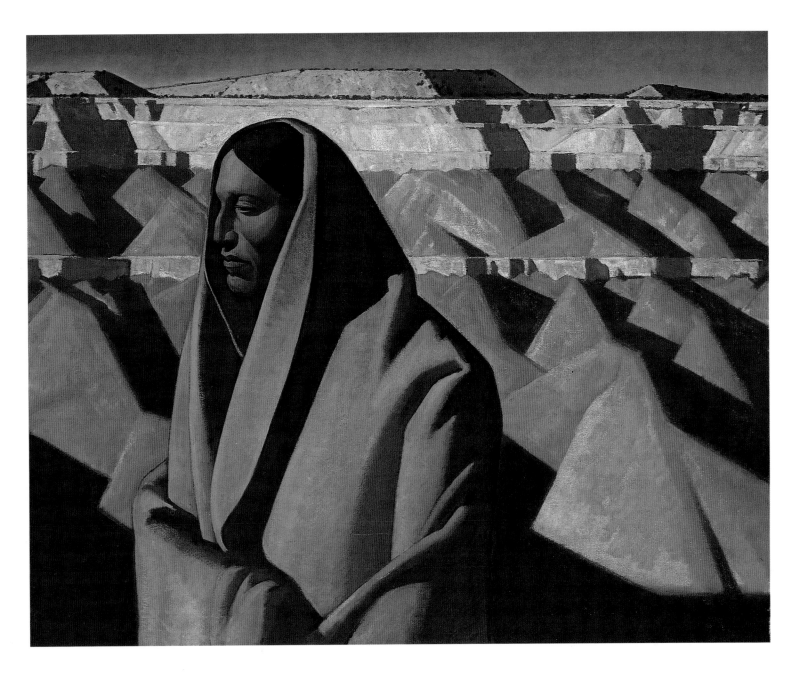

Georgia O'Keeffe
1887–1986

Cow's Skull: Red, White, and Blue

1931

◆•◆•◆•◆

When Georgia O'Keeffe painted this stylized skull in the early years of the Great Depression, she had a hunch it would be noticed. She thought about the city men she had seen in the East who talked of writing the Great American Novel, or Play, or Poem (though she was not sure of the Great American Painting). It seemed to her that for all their patriotic talk, given the opportunity they would all have rushed to live the artist's life in Europe. In fact, they didn't even want to live in New York. So how, she wondered, could the reverently evoked Great American Artistic Endeavor ever happen? O'Keeffe determined to respond herself with a work in progress: a cow's skull against a blue background—an American painting that would demand attention.

And attention it received. One critic from the *New York Sun,* attending O'Keeffe's 1932 show in Manhattan at the American Place Gallery (run by her husband, photographer Alfred Stieglitz), allowed as how her cure for the Great Depression was to wallow in depression and peevishly remarked that, judging by the subject of her pictures, the painter thought about bones as much as Hamlet at the grave of Ophelia. (Perhaps he meant skulls at the grave of Yorick.)

Georgia O'Keeffe was most at home in the West—in the empty, arid reaches of New Mexico. Like hundreds of artists since the nineteenth century, she was entranced by the light, the color, and the imagery of the place. It nurtured both her senses and her spirit. There she created works unlike anything being done by anyone anywhere—delicate but somehow powerful, simple but with levels of meaning deeper than the two dimensions of the canvas, testaments to her unique personal vision.

From her birth in 1887 in Wisconsin's Sun Prairie—a name that prophetically combined light and space—to her death nearly a century later in the desert spaces of New Mexico's Abiquiu, she was a true American original.

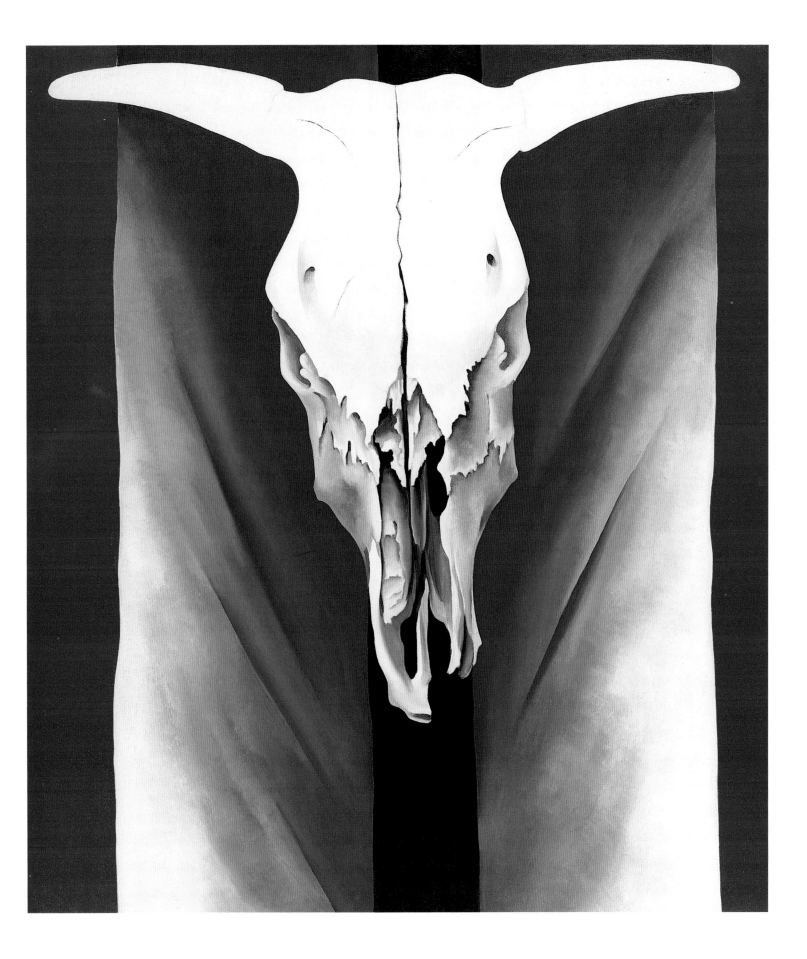

Bernadette Vigil
b. 1955

La Procesión de la Virgen de Guadaloupe

1991

◆•◆•◆•◆

After being dispelled from the province by a massive Pueblo Indian uprising in 1680, it took the Spanish colonizers of New Mexico nearly fifteen years to reestablish themselves in the Valley of the Rio Grande beneath the looming Sangre de Cristo Mountains. Many of the returning settlers filtered out from Santa Fe into the little river and creek valleys that pocked the ragged foothills of the mountains, pasturing their herds of sheep and cattle, scratching out miniscule farms, slowly coalescing into tiny communities—Nambé, Cundiyo, Chimayo, Espanola, Ranchos de Taos, many more. Repeatedly, sometimes allying themselves with the Pueblo people who had once tossed them out of New Mexico, they fought off Navajo and Apache raids. And in the shadow of the biblical mountains they built a life that survived with astonishingly few changes through the remaining years of Spanish rule; the Mexican revolution of 1821; the two decades of American trappers and traders that followed; the American occupation of 1846; the Mexican War; and currently more than a century-and-a-half of governance by the United States.

It was, and in many ways remains, a profoundly simple life. The ways of the mountain villages and their people still make up "a country of ancient Catholicity," as a priest described it in 1851. The faithful built their tiny chapels and churches and kept them up even in the dark decades when the visitation of priests was a rare event. The people themselves cared for the sick, collected money and food for the destitute, and buried the dead with rituals that may have lacked the high sanctity of a requiem mass but at least comforted the mourners with spiritual form. It was faith and sometimes faith alone that gave the people of the mountains the sense of community and cohesion without which no society, however large or small, can survive.

That validation of community is the message in this somber scene of procession depicted here by Santa Fe artist Bernadette Vigil. On this holy day—as on all holy days—the people turn to ritual and to one another to find solace and assurance.

Oil on canvas.
30 × 30 in.
Courtesy of Owings-Dewey Fine Art, Santa Fe, New Mexico.
Copyright © 1995 Bernadette Vigil.

100

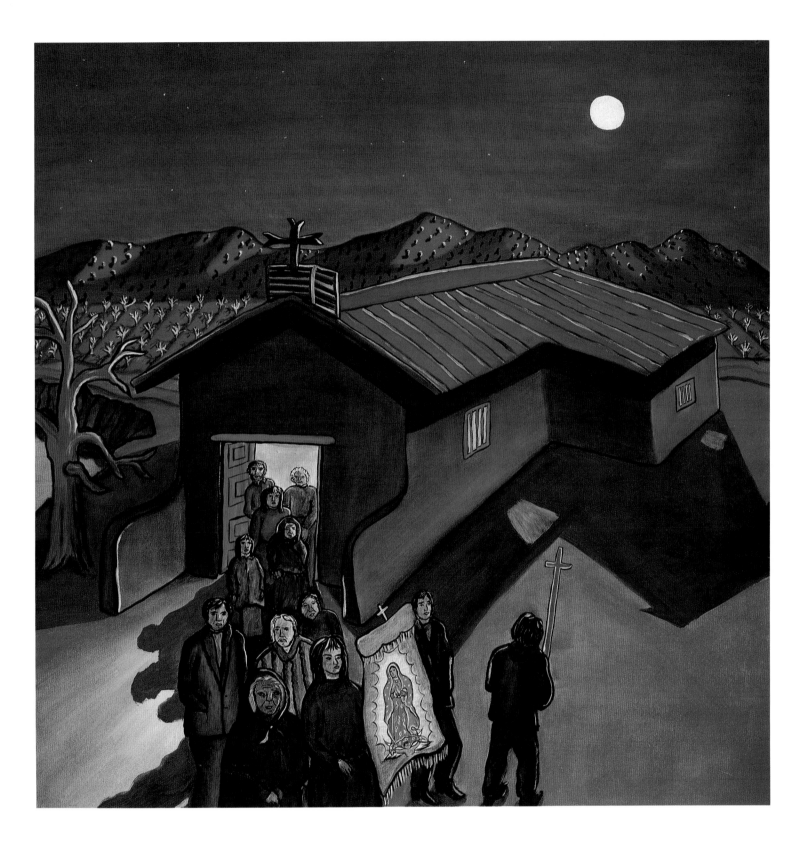

Walter Ufer
1876–1936

Oferta para San Esquipula
1918

◆·◆·◆·◆

When they reached New Mexico in the dusty Southwest—though many had studied and traveled in some of the most beautiful regions in the world—an eclectic mix of late nineteenth- and early twentieth-century creative artists felt they had finally found the home of their hearts. The region's natural splendors—the fresh, dry piñon-and-juniper-scented desert air; the clear light, which was constantly changing, like an enormous lens; and the splendid variety of the scenery and its occupants embodied the West of their wildest imaginings. The artists' reactions to this encounter—perhaps at least partly induced by the lightheadedness that comes with altitude—were as "individual and as varied as the land itself," according to art historian Charles C. Eldredge, and their personal and artistic horizons expanded.

Some early arrivals made romantic views of the area for the railroads to use in illustrated pamphlets promoting tourism or for other specific purposes. Later, more serious artists attempted to express their personal reactions to the region and its people, and many of them settled in Taos. Nestled beneath the Sangre de Cristo Mountains, the town of Taos was both a small New Mexican village and—just outside the non-Indian part of the town—an Indian Pueblo. Its appeal was immediate and almost irreversible. Many of the painters, writers, sculptors, and art lovers who discovered it never left, and those who did almost always returned.

Walter Ufer came in 1914. Born in Kentucky in 1876, he studied art in Germany and then traveled throughout Europe on an extensive painting tour. When he returned to Chicago, the mayor was so impressed by Ufer's work that he urged him in the direction of Taos and even paid his way. The painter was immediately asked to join the Taos Society of Artists, established at the turn of the century. Taos proved perfect to Ufer, who liked to create in the open air and felt that studio paintings somehow "leaked" their vitality; certainly, nothing vital has been lost in this scene of a tiny chapel in the mountains drenched with light under bright blue skies.

Oil on canvas.
25 × 30 in.
Courtesy of The Anschutz
Collection, Denver, Colorado.

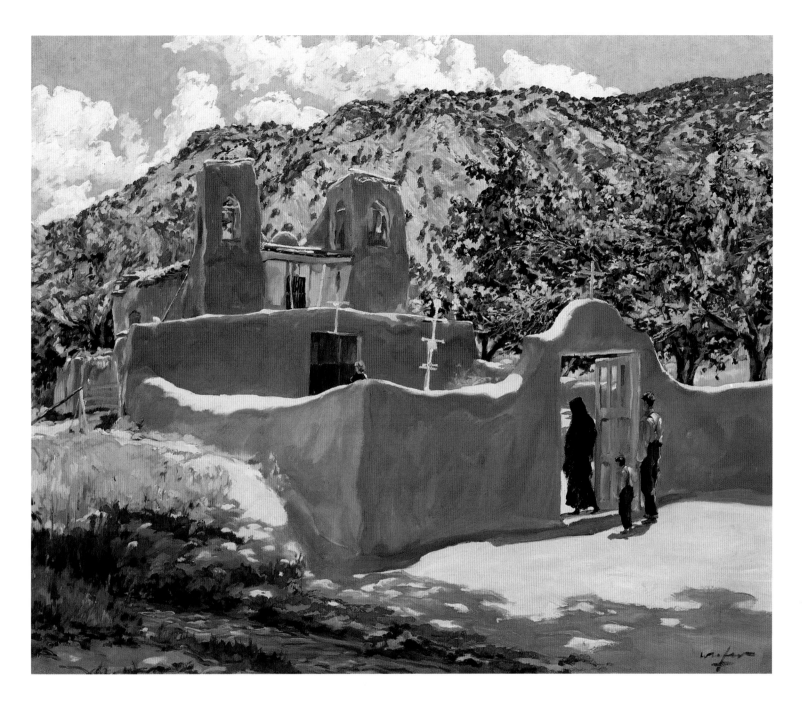

Victor Higgins
1884–1949

Pueblo of Taos

Before 1927

◆·◆·◆·◆

Making up one of the oldest settled communities in the United States, the people of Taos Pueblo trace their bloodlines to prehistory as descendants of the Anasazi—the "people who have vanished" or "the ancient ones." When farming and pottery-making became part of their culture, the ancient ones stopped living in pit houses and began to build the large apartmentlike dwellings the Pueblo people of the Rio Grande Valley still occupy. The Spanish conquistadors who first saw these great adobe communities called their people "pueblo"—Spanish for "village"—and the name remained.

After the Mexican War of 1846–1848 had given the United States the territory of New Mexico, the Pueblos of the valley were at first treated with benign neglect. In 1869, the government even recognized the Pueblo people as American citizens who held full title to their tribal lands. That changed after 1882, when the Dawes Severalty Act declared that assimilation into the dominant white culture was the only way Native Americans could hope to survive. The children of the Pueblos, like those of other Indians, were taken away to boarding schools to be leached of their own culture. Missionaries, too, tried mightily to win the people away from their ancient beliefs and ceremonies.

Somehow, among the Pueblo people it did not quite work. The many Christian denominations were confusing to the Indians—"too many Jesuses," they were given to complaining—and when John Collier, Commissioner of Indian Affairs during the New Deal years, ended assimilation policy and encouraged the revival of the original traditions among Native Americans, most Pueblos returned to old traditions—some of them now overlaid with a slight patina of Catholicism. That is Taos Pueblo today, self-contained and deeply committed to the preservation of the old ways in the midst of the twentieth century.

Trained extensively in both the United States and Europe, Chicago artist Walter Higgins joined the New Mexico "colony" of Anglo painters permanently in 1914 and was swiftly inducted into the Taos Society of Artists. The shapes and colors of the landscape, he later explained, inspired him. "And besides this," he added, "there is a constant call here to create something." Like most of his contemporaries, he turned to Taos Pueblo for subject matter more than once, as in this highly stylized, impressionistic view.

Oil on canvas.
43 ¾ × 53 ½ in.
Courtesy of The Anschutz
Collection, Denver, Colorado.

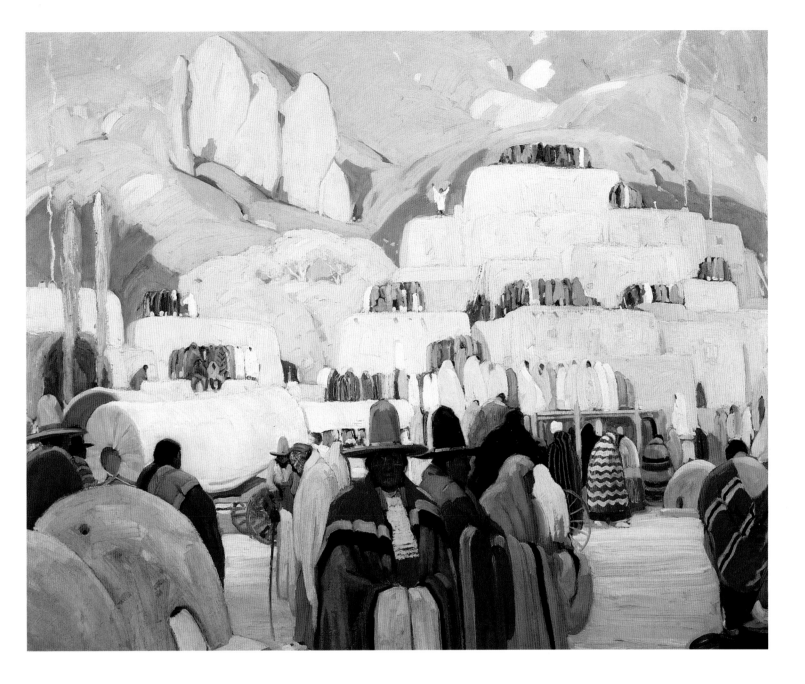

Ernest L. Blumenschein
1874–1960

Sangre de Cristo Mountains
1925

◆•◆•◆•◆

American-born Ernest Leonard Blumenschein gave up music to study art in Paris and returned to the United States to take up a living as a magazine and book illustrator like his contemporaries, W.H.D. Koerner and N.C. Wyeth. In 1897, *McClure's* magazine sent him to New Mexico and Arizona, where he established a studio in Ranchos de Taos and became one of the six charter members of the Taos Society of Artists. New Mexico transformed Blumenschein. He became so infatuated with the power of the landscape that his style began to move from the purely illustrative to something approaching the mystical, particularly when he turned his eye toward the lifeways of both the Pueblo Indians and the Hispanic residents of the mountain communities.

In *Sangre de Cristo Mountains* Blumenschein captured a moment in one of the oldest—if yet unsanctioned—rituals in the Hispanic Southwest: the Penitente procession. The evolution of *Los Hermanos Penitentes,* the Penitent Brothers, was the child of isolation. Left pretty much to themselves in both secular and religious matters for decades, the people of the mountains borrowed a little loosely from the teachings of St. Francis of Assisi and the traditions of self-flagellation brought to this continent by Spanish conquistadors. By the 1830s, they had produced a somewhat grim folk rite whose ceremonials were condemned by the Church and therefore practiced even more zealously by the Brotherhood well into the twentieth century.

Each year during Easter Week, the men of the Brotherhood would lock themselves in windowless little buildings called *moradas* and beat themselves repeatedly, seeking to share in the glory of Christ's pain on his week-long journey to Calvary. On Good Friday they would emerge, often bleeding and exhausted, and, still flagellating themselves, join a slow procession to a little *calvario* outside each village. At the head of the procession would be a man who had been chosen to play the role of Christ. After carrying a big wooden cross to the hill, he would be lashed tightly by his hands and feet to the cross, which would be raised in a mock crucifixion until the loss of circulation caused the Christ figure to faint.

Oil on canvas.
50 ¼ × 60 in.
Courtesy of The Anschutz
Collection, Denver, Colorado.

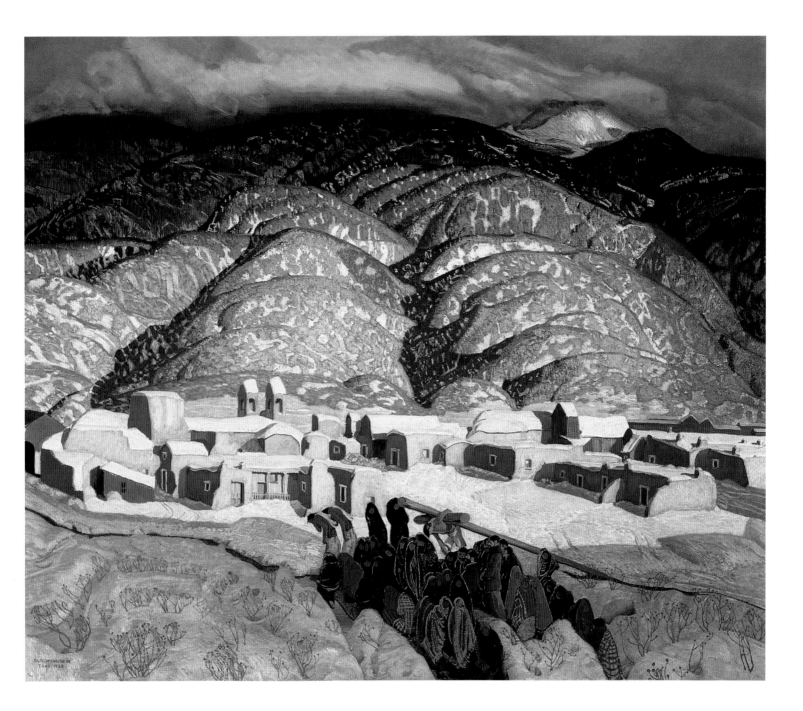

Ben Shahn
1898–1969

Years of Dust
1936

◆·◆·◆·◆

Depression, drought, and dust formed the terrible trilogy of the 1930s, changing lives forever, and uprooting families from their disappearing land. A newspaperman coined the term "Dust Bowl" while visiting Texas, Oklahoma, Kansas, Colorado, and New Mexico in 1935—the peak year of the dust storms, when the winds piled up clouds called "black rollers" and scooped up dry, overfarmed, and overgrazed land in one part of the Great Plains and deposited it in another. Sometimes, wind carried it clear to the east coast; a storm in 1934 deposited an estimated 350 million tons of Great Plains soil on eastern cities. "If you would like your heart broken," journalist Ernie Pyle wrote from Kansas in 1936, "just come out here. It is the saddest land I have ever seen."

"Blown out, baked out, broke"—this was the terrible progress for tens of thousands of American farmers. How could it happen in such a fertile country? In the farmlands, the soil was worn out from overplowing, overplanting, and overharvesting when crop prices were high during the years of World War I, and such practices continued during the 1920s even when prices dropped. In the rangelands, years of overgrazing by livestock did the same. "Grass is what holds the earth together," one ranchman said. But the earth was now too tired to grow any.

The government tried to help. The Resettlement Administration, created in May 1933, aimed to move half a million families from their worked out land and give them a new start. Poorly managed and even more poorly funded, the program eventually moved only 4,441 families—some of them all the way to Alaska. In 1937, it was folded into the Farm Security Administration (FSA).

Like Dorothea Lange, Walker Evans, and others, painter and photographer Ben Shahn spent several years as a field photographer for the FSA in the middle of the 1930s. As both photographer and painter, he was a Social Realist who believed that to maintain integrity an artist was committed to provide "some of the moral stamina our country needs," and Shahn held to that credo throughout his life as an important voice against injustice wherever he found it. *Years of Dust,* with its gaunt farmer reading of yet another dust storm, the haunting child at the window, and the background of billowing "black rollers," is a FSA poster that was based on an original Shahn painting called *Dust.* The poster was used in the campaign to promote the New Deal's inadequate but earnest efforts to relieve the agony of the Dust Bowl years.

Poster. Photo-offset color printing. 38 × 27 ⅞ in.
Library of Congress, Washington, D.C.

YEARS OF DUST

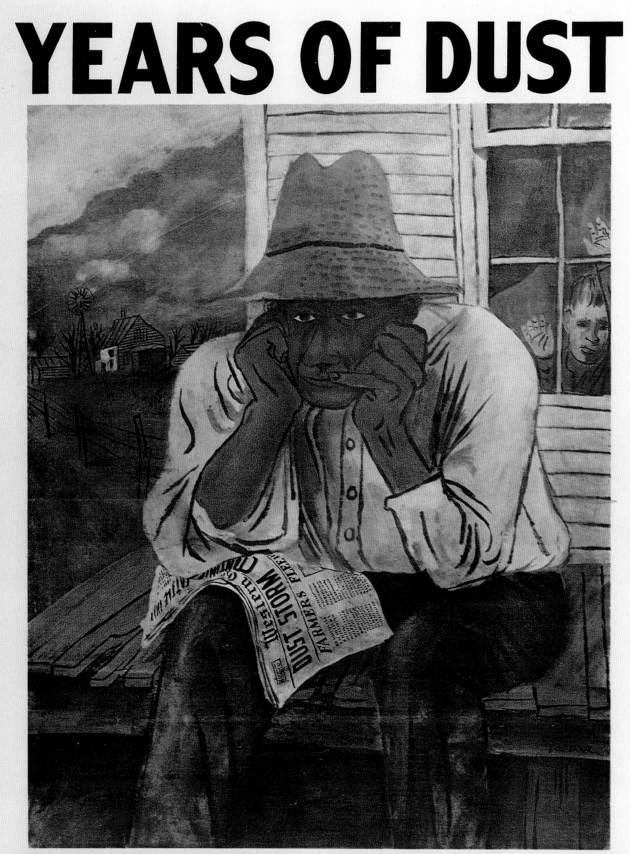

RESETTLEMENT ADMINISTRATION
Rescues Victims
Restores Land to Proper Use

Red Grooms
b. 1937

Wheeler Opera House

1984

◆•◆•◆•◆

I just love history," Red Grooms told interviewer Paul Cummings for the Smithsonian Institution's Archives of American Art more than twenty years ago. "I like [historical] periods of time and trying to get involved in those textures." His *Wheeler Opera House* has plenty of texture—and all of the elements typical of Grooms's unique work. The scene is exuberant, brimming with energy and life, raucous, heavily detailed, and riotous with color. It overflows with his loves: of theater, crowds of people, music makers and trouble makers, animals, lights, action—both on the stage and in the stalls—a cornucopia of life and art celebrating a happy occasion.

The opera house is a real place, not just a burst of Groomsian imagination, and his three-dimensional lithograph commemorates its opening in another incarnation. It was built in 1889 at the height of the bonanza days of Aspen, Colorado, when for a short while the Rocky Mountain town was the world's largest silver camp, mining $10 million a year and enjoying a population of more than eleven thousand people. Then in 1893 the Sherman Silver Purchase Act, which had provided for the unlimited purchase of silver by the government, was repealed. Fourteen years after the discovery of silver had founded the town, the glory days were gone, the boom was bust, and the millionaires were no more. Nobody went to the opera and the town fell asleep.

In 1984, the opera house was refurbished, restored, and reopened in modern Aspen, and it could have had no better commemoration than Grooms's lively attempt to recreate its spirit in its heyday. The big worried blonde on a rather discouraged horse flees across logs to escape a big, shaggy grizzly—or a man in a bear suit. The hero either shouts encouragement or sings, while the orchestra plays beneath the flag-and-flower-bedecked stage. The audience—nobs in the boxes, groundlings in the pit—reacts in various ways, from hats-in-the-air enthusiasm to boots-on-the-balcony boredom.

In Red's raucous ruckus, the artist gets it all.

Color 3-D lithograph, Edition 30.
17 1/2 × 20 × 4 1/2 in.
Shark's Inc. Boulder, Colorado.
© 1996 Red Grooms/Artists Rights
Society, NY.

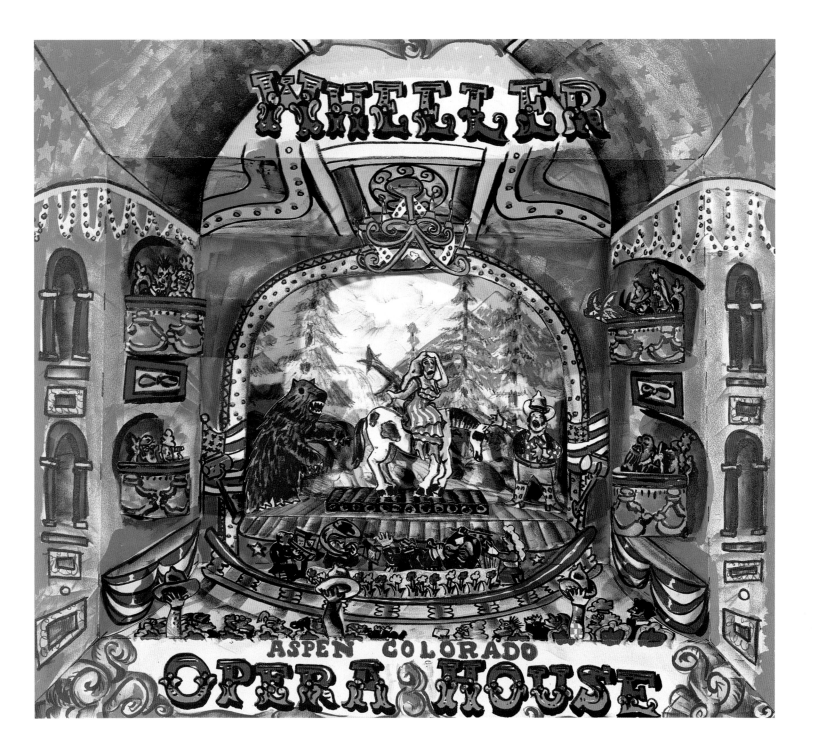

David Hockney
b. 1937

Pearblossom Hwy., 11–18th April, 1986

1986

◆·◆·◆·◆

By the time he left London for Los Angeles in 1963, British painter David Hockney had already made his reputation, having won the coveted gold medal from London's Royal College of Art in 1962, as well as many other awards. An inventive and sometimes startling artist whose style always has defied glib analysis even by art critics, Hockney found Los Angeles, the westernmost part of the West, a challenge even to his lively imagination.

The city, constantly changing, its population extraordinarily mobile and shifting, seemed to him to be largely unperceived even by those who lived there. "[T]here were no paintings of Los Angeles," he said in an interview in *The Listener* (not entirely true, of course, though Los Angeles has yet to be given the kind of painterly identity enjoyed by Chicago, San Francisco, and New York). "People then didn't even know what it looked like. And when I was there they were still finishing up some of the big freeways. I remember seeing, within the first week, a ramp of freeway going into the air, and I suddenly thought: 'My God, this place needs its Piranesi . . . so here I am!'"

Whether Hockney became to Los Angeles what Piranesi was to Rome is debatable, but there can be no gainsaying the fact that when he got out of the city to wander into the hinterlands, he brought an entirely fresh and slightly ironic vision to the visual interpretation of at least part of the West. *Pearblossom Hwy.,* a photographic collage showing a stretch of the old desert byway that connects Cajon Pass in the San Bernardino Mountains to Tejon Pass in the Tehachapi Mountains across the southwestern quadrant of the Mojave Desert, may well be a wry artistic comment on the region's vulnerability to earthquakes. Even so, this Hockney landscape is as fractured and essentially incoherent as many believe the modern West to be. After thousands of years of human habitation, the West is still a land in a state of becoming.

Photographic collage.
78 × 111 in.

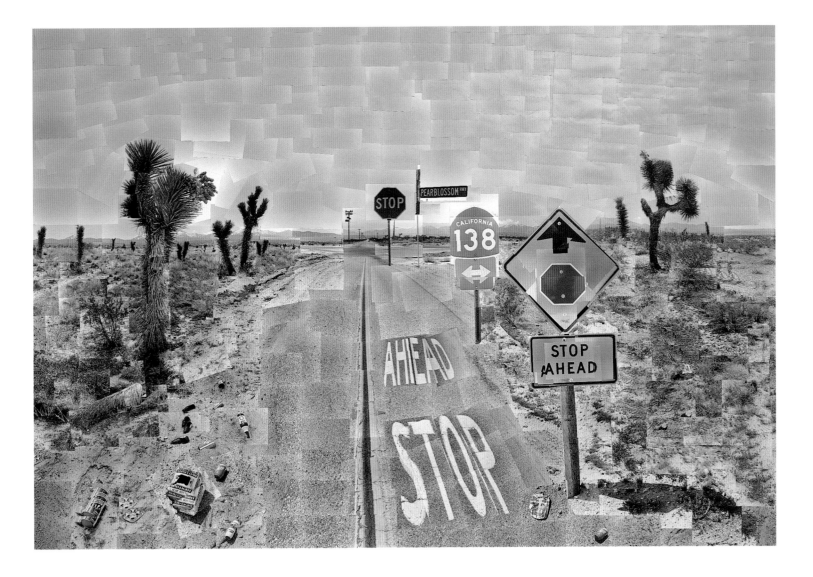

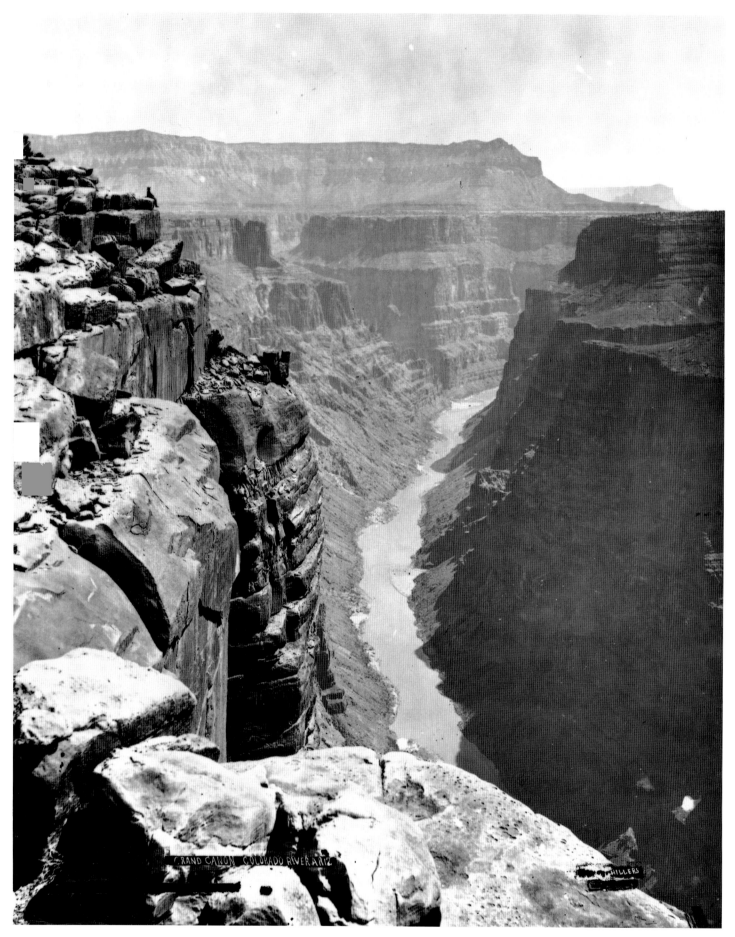

John K. Hillers. *Grand Canyon, Colorado River, Arizona, 1871–79.*
Photograph. U.S. Geological Survey.

Index

Thomas Eakins. *Home Ranch*. 1888. Oil on canvas. 24 × 20 in. Philadelphia Museum of Art. Given by Mrs. Thomas Eakins and Miss Mary Adeline Williams.

Page numbers in *italic* indicate illustrations.

Photo Credits

Archive Photo: p. 85; Art Resource, NY: pp. 15,
23, 41, 55, 91; Photo, M. Lee Featherree: p. 29;
Photo courtesy David Halbach: p. 75; Photo,
Lassiter-Shoemaker Photography: p. 87; Photo,
Herb Lotz: p. 79; Photo, James O. Milmoe: pp.
61, 73, 77, 103, 105, 107; Photo, Robin Stancliff:
pp. 19, 95; Photo, Charles Swain: p. 65.